Books of Hours

JANET BACKHOUSE

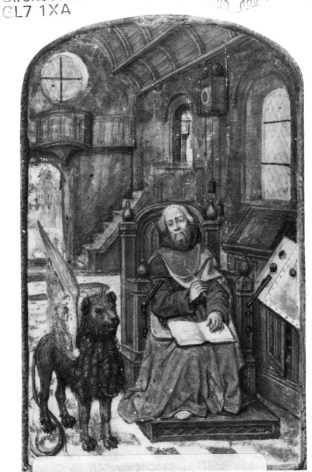

The British Library

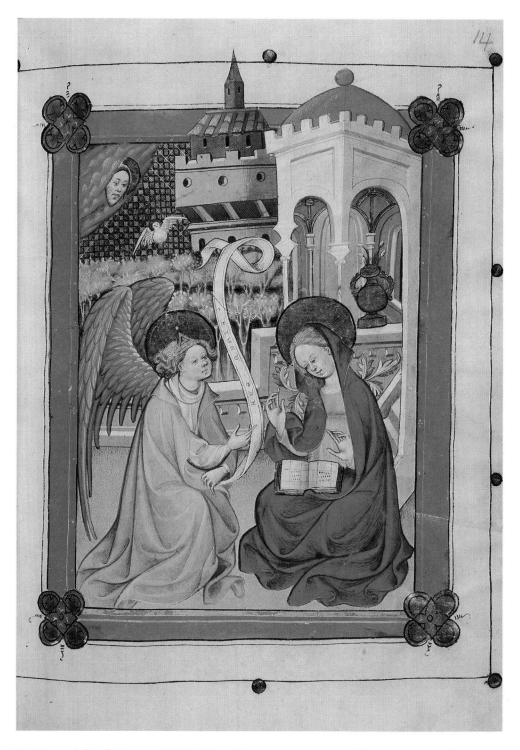

The Annunciation. Spain; second half of the 15th century. 195 × 140 mm. *Egerton MS 2653, f.14.*

 The Book of Hours was the standard book of popular devotion in western Europe during the late Middle Ages and Renaissance. Essentially it contained a series of short services, the Little Office of the Blessed Virgin Mary, designed to be recited at different times of the day and night. These services first appeared during the 10th century and two important early copies, written in England shortly before the Norman Conquest, are preserved in manuscripts now in the British Library. During the late 12th and early 13th centuries the Little Office, originally used by members of the religious orders and by the clergy, became more widely popular and was frequently appended to copies of the psalter, which was at that time the universal choice of private prayer book. The earliest independent Books of Hours date from the middle of the 13th century (see **39**) and thereafter this type of manuscript rapidly became very fashionable, especially in France and the Low Countries. During the 14th and 15th centuries copies were made in their hundreds to suit all tastes and pockets, ranging in quality from magnificently illuminated masterpieces, individually ordered by the wealthy and great, to modestly written small volumes with little or no decoration. The text is even occasionally found in the form of a prayer roll. The invention of printing widened the market still further and, particularly in France, the decades on either side of 1500 saw the production of a flood of Books of Hours, many of them decorated with superb woodcuts and engravings and a few adorned with hand-painted miniatures and borders. It is with justification that the Book of Hours has been described as the biggest best-seller of its age.

As reflected in its popular title, the core of a Book of Hours – the eight services which make up the Little Office of the Blessed Virgin Mary – was designed to be said at particular times of day. These services are modelled on the fuller services said daily by the clergy – the Divine Office, which is contained in the Breviary – and they share the same names: Matins, Lauds, Prime, Terce, Sext, None, Vespers and Compline. Both comprise psalms and scriptural readings, with the addition of non-scriptural compositions such as hymns. The Little Office is however shorter, considerably simpler and much less variable than the Divine Office itself.

In the Middle Ages worship was not rigorously uniform and, though the western church naturally looked to Rome for overall guidance, other centres such as Paris in France or Salisbury in England were likely to command a more immediate loyalty. Religious orders also had their own traditions of worship. In Books of Hours all these different practices may be reflected by variations, some of them quite minor, in the text of the Little Office, indicating the 'use' for which the manuscript was made. Simple tests to establish 'use', based mainly on the texts of late printed Hours of known provenance and on manuscripts in which the 'use' is actually specified, have been available for many years. Recently more detailed investigation of large numbers of texts has begun to suggest more sensitive tests, which will in time help scholars to establish the origins of some of the more problematic books, adding greatly to our understanding

of the development of some of the finest book painting of the Middle Ages and Renaissance, for which these volumes are the chief source.

In addition to the Little Office of the Blessed Virgin Mary, a Book of Hours usually contains a variable number of other texts and devotions. These commonly include a calendar, showing the feast and saints' days throughout the year, extracts from the Gospels, short Hours in honour of the Cross and of the Holy Spirit, the Seven Penitential Psalms with litany and collects, the Office of the Dead, and special prayers to the Virgin, the Holy Trinity and various saints. Most of this material is usually in Latin, though one or two popular vernacular prayers, such as the 'Doulce Dame', are commonly included. It is indeed possible for the entire contents of a Book of Hours, including the Little Office itself, to be in the vernacular (41).

A typical illuminated Book of Hours is likely to include a major miniature to mark each of the main divisions of the text. Those illustrating the Little Office are usually drawn either from the Christmas story or (particularly in manuscripts designed for the English market) from the story of Christ's Passion. Calendars are often enlivened by miniatures of the labours of the months. There may also be elaborate border decoration, frequently extended to every page of the book. The scale and quality of the decoration was of course dictated by what an individual customer could afford to pay. In many of the more splendid Books of Hours coats-of-arms, mottoes and devices, and sometimes even portraits of the owner and his or her family, were included to order.

All the illustrations in this book are chosen from manuscripts in the collections of the British Library, where some three or four hundred Books of Hours of various styles, dates, origins and sizes are to be found. They are arranged roughly to reflect the order in which the different components of a Book of Hours are likely to appear and an attempt has been made to provide a reasonably comprehensive sample of the enormous range of medieval painting for which they are a principal source.

Some of the most celebrated Books of Hours in the Library's collection are famous not only for the beauty of their decoration but also for their association with patrons whose careers had a special significance for the history of their own times. Most outstanding of all is the Bedford Hours, produced in the leading Parisian workshop of the early 15th century for John, Duke of Bedford, brother of King Henry V of England and Regent in France for his infant heir, Henry VI, and his wife Anne of Burgundy. It was almost certainly intended to mark the occasion of their marriage in 1423 and may very well have been a gift from the bride's brother, Duke Philip the Good of Burgundy, England's principal ally at the time. The marriage had been arranged to cement the political alliance, though, fortunately for Anne and her husband, it did turn out to be one of the happiest love matches of the period. The Bedford Hours contains nearly 300 leaves, every one of which is illuminated. In addition to its 38 large miniatures, most of which complement the conventional texts of a Book of Hours, it includes more than 1200 tiny marginal pictures, each little more than an inch in diameter, illustrating scenes from the Old and New

Testaments. Among the large miniatures are portraits of the Duke and Duchess at prayer before their patron saints. Bedford appears (1) not with his personal patron, St John the Evangelist, but with St George, traditional patron of England itself, especially venerated by Henry V, and patron of the royal Order of the Garter, in the blue robe of which he is here (uniquely) shown. This is clearly intended to reflect Bedford's official status as England's Regent in France and the manuscript has been found to contain a number of other political references. The most pointed of these is its final major miniature (2), which illustrates the story of King Clovis of France and the fleurs-de-lys. According to legend Clovis, newly converted to Christianity, received the fleurs-de-lys device which was to become the accepted symbol of the French monarchy at the hands of his wife, the Burgundian princess Clothilda. By his own marriage to Anne of Burgundy, Bedford was himself in a sense receiving the fleurs-de-lys, as the current English ascendancy in France depended very largely upon the continued support of the Burgundian Duke, with whose help Henry V had consolidated his claim to the French crown.

A few years later the same Parisian workshop produced a much smaller but almost equally elaborate Hours for one of Bedford's principal opponents, Jean Dunois, Bastard of Orleans, the companion-in-arms of St Joan of Arc. He is portrayed in the margin of the miniature of the Last Judgement (3), ushered into the presence of the Almighty by the patron saint he shared with his English adversary, St John the Evangelist.

During the final quarter of the 15th century book painters in Flanders dominated the market in Books of Hours. Foreign trade delegations based there ensured that their work was ordered for use all over Europe, and a sequence of marriage alliances between the descendants of Duke Philip the Good and the royal houses of Austria and Spain resulted in the production of a number of manuscripts of superb quality and great historic interest. A particularly pretty little book is the Hours of Joanna of Castile (Joanna the Mad), made for her soon after her marriage in 1496 to Duke Philip the Fair of Burgundy, the son of the Emperor Maximilian I and Duchess Mary of Burgundy. Joanna appears in her Hours (4) accompanied by her patron saint, once again John the Evangelist, as she kneels in prayer opposite a picture of the Virgin and Child which is derived from a design for a large-scale panel painting. Joanna's son, Charles V, was to be one of the most powerful rulers in the history of Europe, uniting in his hands the realms of his paternal grandfather, the Holy Roman Emperor, his maternal grandparents, Ferdinand of Aragon and Isabella of Castile, and his father, the Duke of Burgundy. Joanna herself is a tragic figure. Heartbroken at the death of her husband in 1506, she spent the remaining fifty years of her long life in a pitiful state of madness. However, an English connection did ensure one happy memorial to Joanna, although she is not mentioned by name. She is 'the King of Spain's daughter' of the well-known nursery rhyme 'I had a little nut tree', inspired by an unexpected visit which she paid to the court of Henry VII in 1506, when she and Philip were blown off course by a storm as they sailed from Flanders to Spain.

A personal reference of a somewhat different nature is included in the

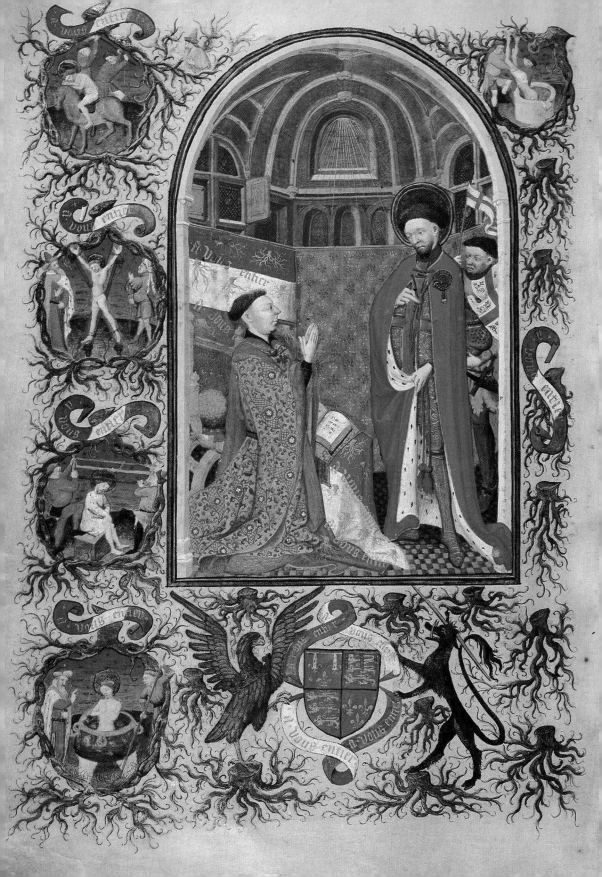

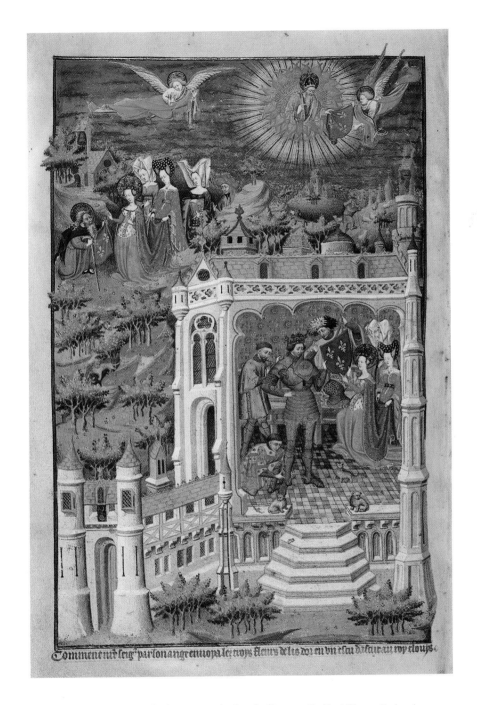

1 *Left* John, Duke of Bedford, at prayer before St George. *Bedford Hours*. Paris; about 1423. 260 × 180 mm. *Add. MS 18850, f.256v.*

2 *Above* The Legend of the Fleurs-de-Lys. *Bedford Hours*. Paris; about 1423. 260 × 180 mm. *Add, MS 18850, f.288v.*

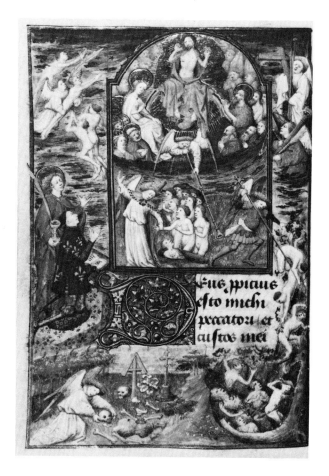

3 The Last Judgement. *Dunois Hours*. Paris; about 1450. 135 × 95 mm. *Yates Thompson MS 3, f.32v.*

Hours of Alfonso V of Aragon, Joanna's great-uncle (**5**). A splendid miniature at the beginning of the Office of the Dead shows Alfonso's father, Ferdinand I, who died in 1416, lying in state in full regalia while a service is said over his body by a Pope, attended by a bevy of church dignitaries. This probably reflects Ferdinand's vital role in the ending of the great schism in the western church. The last of the Avignonese Popes, Benedict XIII, elected in 1394, was by birth an Aragonese nobleman named Pedro de Luna. He firmly resisted all efforts to persuade him to abdicate in the cause of unity and fled to his Spanish stronghold, Peñiscola in Valencia, where he clung to the Papal title until his death in 1422 or 1423. Although he had given political support to Ferdinand, the Aragonese king eventually agreed not to uphold his claim, forging the final link in a chain of events that led to his deposition by the Council of Constance in 1417 and the election of Martin V, under whom the church was finally reunited. Alfonso's Book of Hours apparently celebrates his own acquisition of the kingdom of Naples in 1442. He was well known as a scholar and connoisseur of fine books. He laid the foundations of one of the most extensive libraries of the Renaissance, further developed by his son,

Ferdinand I of Naples, who succeeded him in 1458 and died in 1494.

However, not all of the patrons whose portraits have come down to us can claim true historical significance. Many were simply persons of wealth and position who could afford to employ the finest artists of their day and who may now be remembered mainly for their association with an exceptional illuminated book. The original owner of the Saluces Hours (*front cover*) was one of these. She was, according to the plentiful heraldic references in her Hours, Amadée, daughter and heiress of Mainfroy de Saluces, Marshall of Savoy (*d.* 1455). Her daughter, Catherine de Polignac, married as her second husband Pierre d'Urfé, Grand-Ecuyer of France (*d.* 1508). Arms of both Saluces and d'Urfé occur in the manuscript, the latter clearly added at a later date. Amadée's portrait appears at the beginning of the prayer 'Obsecro te', where she is shown kneeling before the Virgin and Child, supported by St Dominic, founder of the Dominican Order, and St Bernardino of Siena, a Franciscan friar who died in 1444 and was canonised in 1450. The manuscript, which is of unusually large size, is most richly decorated. Every one of its pages, more than 400 in all, has an elaborate border of flowers, fruits, animals and grotesques painted in gold and brilliant colours. There are 34 large

4 Joanna the Mad at prayer before the Virgin and Child. *Hours of Joanna of Castile.* Bruges; between 1496 and 1506. 110 × 75 mm. *Add. MS 18852, ff.287v–288.*

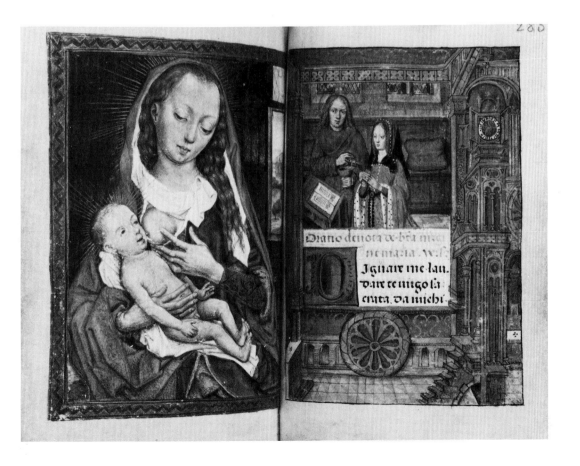

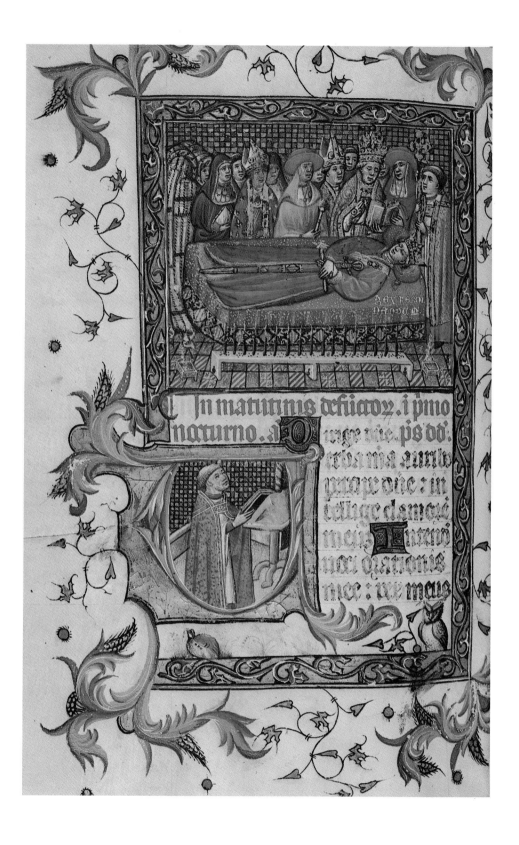

miniatures, many of them depicting unusual scenes from the New Testament (see **47**).

On a much smaller scale, better suited to a book intended for the use of a child, is the Hours of Francesco Maria Sforza, 'Il Duchetto', the son of Duke Gian Galeazzo Sforza of Milan, who is shown hand in hand with his guardian angel (*back cover*). 'Il Duchetto' was not allowed to make his mark on history. He was only three years old when his father died in 1494, and the dukedom to which he was heir was promptly and predictably usurped by his great-uncle, Ludovico 'Il Moro'. However, little Francesco remained very popular with the people of Milan and was seen as a serious rival by Louis XII of France when he in his turn removed Ludovico in 1499–1500. He took the young man to France where he was made Abbot of Noirmoutier, but he died as the result of a hunting accident in 1512. Francesco's Book of Hours, written and illuminated by some of the fine craftsmen employed by the Sforza court, was completely unknown until it was presented to the British Library in the summer of 1984.

Books of Hours in most cases open with a calendar, recording the fixed feasts of the liturgical year and the anniversaries of important saints. Some calendars are selective, including only those saints who are universally venerated, such as the apostles and the martyrs and confessors of the early church, together with saints of particular local interest for the owner of the manuscript. In these calendars the relative importance of the various feast days is indicated by the use of red, blue and gold lettering, gold being reserved for anniversaries of the very highest grade. It is usual for such feasts as the Annunciation and the Assumption, together with those of the apostles and evangelists, to be inscribed in gold, but the use of gold for a feast of purely provincial significance, such as that of St Geneviève of Paris, almost certainly offers a clue to the provenance of the book. Other calendars provide a feast or a saint's name for every day of the year and these are less helpful to scholars. Although they too are usually written out in gold and colours, these are employed solely for their decorative effect and have no liturgical significance. The saints included are frequently extremely obscure and very often also misspelt, the object being to create a visually pleasing page rather than to provide the customer with a practical aid to devotion.

From very early times calendar pages in all kinds of books were ornamented with miniatures, usually portraying the signs of the zodiac and the occupations of the months. The agricultural work of the changing seasons remained the basic source of inspiration for these miniatures during most of the Middle Ages, with a strong and understandable emphasis on the provision of food, drink and warmth, though other contemporary activities such as hunting and hawking were also included. They provide us with much of our information about the details of medieval costume and the trappings of everyday life and work.

A typical example of a calendar page comes from the Hours of Laudomia de' Medici, a cousin of Lorenzo the Magnificent, made in or

5 Ferdinand I of Aragon lying in state. Hours of Alfonso V. Aragon or Naples; about 1442. 225 × 165 mm. Add. MS 28962, f.383v.

about 1502 (6). This covers the first half of the month of August and includes the Feast of the Assumption. In a roundel at the top of the page is the zodiac sign Virgo, shown as a young girl with a unicorn in reference to the legend that a unicorn might be captured only through the intervention of a virgin. In the lower margin is a tiny miniature of the occupation of the month, showing coopers busily making the barrels required for the forthcoming grape harvest, very appropriate to a manuscript made in Florence in the heart of the Tuscan vineyards.

A more conventional choice of scene, showing peasants at work in the harvest field, represents the month of July in a French Book of Hours dating from about 1500 (7), but the artist of this manuscript added a whole range of additional embellishments. On the left-hand page, accompanying feasts in the latter part of June, is a personification of the Moon, driving her chariot through the heavens. The margins enclose miniatures of Adam and Eve being rebuked by the Almighty for listening to the tempting of the serpent, a figure representing Fortitude, and the zodiac sign Leo.

More specialised in interest is the calendar of a Book of Hours written and illuminated in south Germany or Austria at the beginning of the 16th century (8). It is illustrated exclusively with hunting scenes matched to the seasons of the year. November is associated with boar hunting and its miniature shows a solitary man on foot facing an enraged boar caught in a noose. The setting of this scene, in a snowy landscape against a fiery winter sunset, reflects contemporary interest in the portrayal of the natural world. The Hours contains no pictures other than those in the calendar but the margins round every page of text are decorated with paintings of the plants and flowers of the region, many of them apparently drawn from life. The original owner of the manuscript was probably a member of the circle of the Emperor Maximilan (d. 1519), who was addicted to hunting and spent much time enjoying his favourite sport in the mountains of the Tyrol.

Activities suited to the interests of a courtly clientele adorn the calendars of some of the most splendid Book of Hours produced in Renaissance Flanders. The 'Golf Book' (9), written and illuminated probably about 1520 and attributed to the leading studio of the day, that of Simon Bening, offers full-page illustrations of feasting, courting, hunting, hawking, a river party and, for June, jousting. The lists are set up in a detailed Flemish townscape, probably inspired by Bruges, and the main subject is complemented by a tiny marginal panel in which a group of children imitates its elders, staging its own tournament with hobby horses and windmills. Each page of this particular calendar includes an illustration of a contemporary children's game and the resemblance of one of these to the modern game of golf gives the manuscript its popular nickname.

In a great many Books of Hours the calendar is followed by a sequence of extracts from the Four Gospels, arranged to provide a synopsis of the story of man's redemption. These appear not in biblical order but in an order dictated by their content and they are usually accompanied by miniatures

6 August. Hours of Laudomia de' Medici. Florence; about 1502. 180 × 120 mm. Yates Thompson MS 30, f.8.

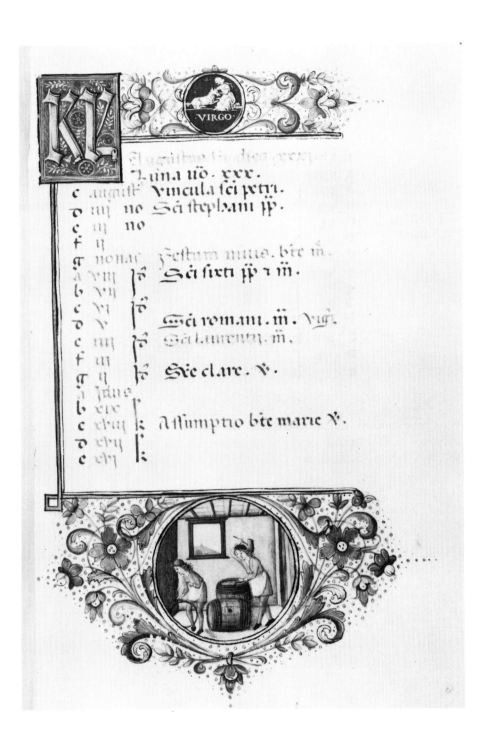

VIRGO

Augustus habet dies xxxi.

Luna ño. xxx.

e	augusti		Vincula sci petri.
o	iiij	no	Sca stephani ppi.
a	iij	no	
f	ij		
g	nonae		Festum niuis. bte m̄.
a	viij	idus	Sci sixti ppi z m̄.
b	vij	idus	
c	vi	idus	Sci romani. m̄. vigi.
o	v	idus	Sci laurentii. m̄.
e	iiij	idus	
f	iij	idus	Sce clare. v.
g	ij	idus	
a	idus		
b	xix		
c	xviij	kl	Assumptio bte marie v.
o	xvij	kl	
e	xvi	kl	

13

of the Four Evangelists, each of whom is likely to appear with his traditional symbol – Matthew with a man, Mark with a lion, Luke with an ox and John with an eagle. These symbols, derived from the visions described in Ezekiel (i, 5 etc.) and in Revelation (iv, 6–10), were associated with the Evangelists at a very early date.

First comes the opening passage of John: 'In the beginning was the Word', proclaiming the godhead of Christ. John is sometimes shown writing in a study and sometimes seated on the isle of Patmos, where he received his apocalyptic vision. His eagle often holds his pen-case or an inkpot in its beak. On the John page from the Bedford Hours (10) both versions are included and the surrounding margins enclose four further subjects from the saint's story, ending with his martyrdom in a vat of boiling oil.

John is followed by Luke, who contributes the story of the Incarnation, beginning with the Annunciation. Luke was a physician by trade, but he is believed also to have been an artist and is traditionally credited with painting from the life a portrait of the Virgin Mary. A miniaturist working in central France towards the end of the 15th century (11) was one of the many who chose to show him at work on the portrait, brush and palette in

7 June-July. France; about 1500. 165 × 110 mm. *Add. MS 11866, ff.6v–7.*

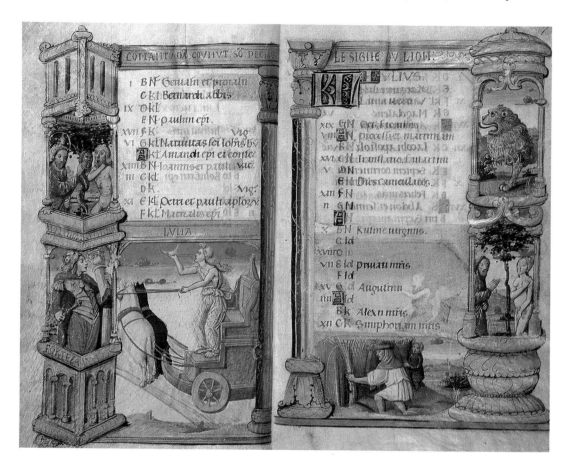

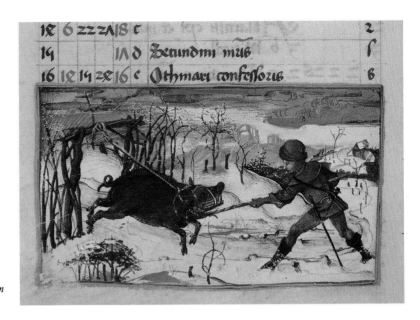

8 November. Southern Germany or Austria; about 1500. 195 × 135 mm. *Egerton MS 1146, f.13v (detail)*.

hand, the half-finished picture held steady on his lectern by a weighted cord. The same manuscript includes a most unusual miniature of Matthew as a collector of taxes.

Matthew, whose gospel extract continues the Christmas story with the coming of the Magi, is more conventionally portrayed as an author (12) in the Hours of Bona Sforza, written and illuminated about 1490. This tiny, exquisite and exceptionally rich little book, containing more than 60 miniatures and 139 elaborately ornamented borders, was made for Bona of Savoy, widow of Duke Galeazzo Sforza of Milan and grandmother of 'Il Duchetto', by Giovan Pietro Birago, who executed many commissions for members of the Sforza family. An undated letter records that a number of the valuable illuminated pages of this particular manuscript were stolen from him before he could deliver it to his patron, but Bona took the incomplete Hours with her when she retired to end her days in her native Savoy.

The last of the gospel extracts, telling how Christ appeared to the disciples after the Resurrection and commanded them to go forth and spread the gospel message throughout the world, is provided by Mark. He too appears as a writer (13) in the Hours of Joanna the Mad, in a delicate little picture framed by a complicated still-life arrangement of shelves and niches, open cupboard doors, pots, jars, strings of beads and even a peacock. A second Flemish view of the same saint, in a study complete with contemporary clock, may be seen on the title page of this book.

In the great majority of Books of Hours the eight Hours themselves, making up the Little Office of the Blessed Virgin Mary, are introduced by eight scenes from the Christmas story, showing the Virgin in her role as the mother of Christ. Although there may be occasional slight variations in

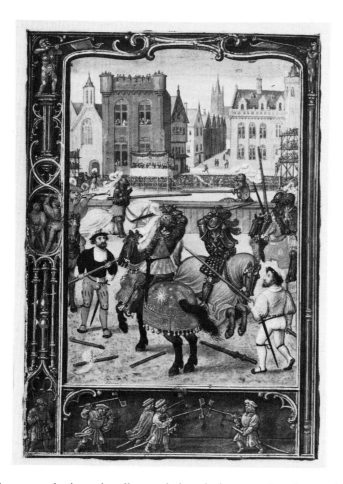

9 June. *The Golf Book*.
Bruges; about 1520.
115 × 80 mm. *Add. MS
24098, f.23v.*

10 St John the Evangelist.
Bedford Hours. Paris; about
1423. 260 × 180 mm. *Add.
MS 18850, f.19.*

order or emphasis, and endless variations in iconography, the standard
sequence is: Matins – the Annunciation; Lauds – the Visitation; Prime –
the Nativity; Terce – the Shepherds; Sext – the Magi; None – the
Presentation; Vespers – the Flight into Egypt; and Compline – the
Coronation of the Virgin.

A simple and extremely beautiful Annunciation (*frontispiece*) occurs in a
little-known Hours written and illuminated in Spain. The script and
decoration of the body of this book suggest a date quite late in the 15th
century but its six miniatures, all inserted on separate sheets of vellum,
seem by comparison with work from northern Europe to be considerably
earlier. Spanish book painting was however very much indebted to outside
models and influences. Similarities between these miniatures and some of
the work in the mid-15th century Hours of Alfonso V, attributed to
Aragonese artists, which also appears rather archaic by northern stan-
dards, suggest that a date in the second half of the century is by no means
unlikely.

Easier to place is a fine miniature typical of the best Parisian work of the
early 15th century (**14**), which appears on one of six detached leaves from a

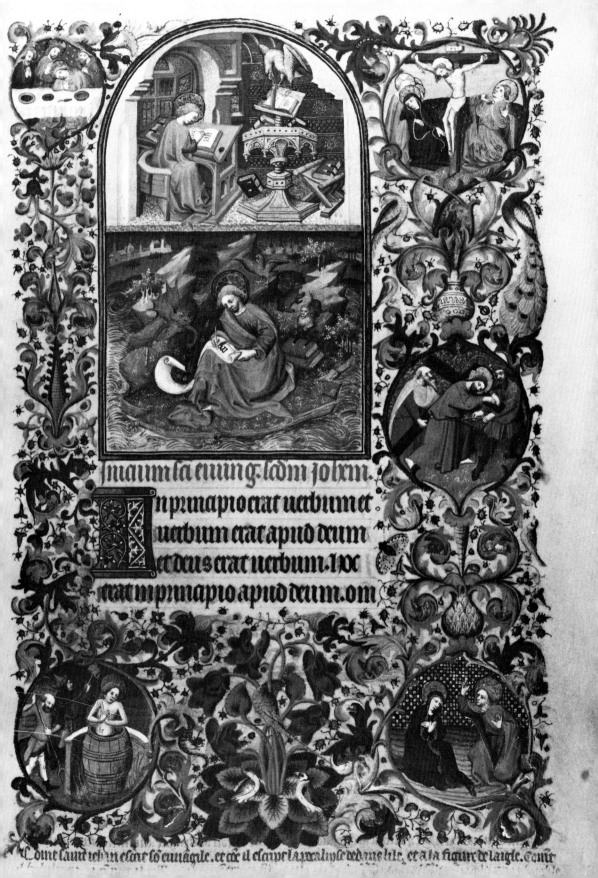

maum la euing lcdni Johm.

In principio erat uerbum et
uerbum erat apud deum
et deus erat uerbum. hoc
erat in principio apud deum. om

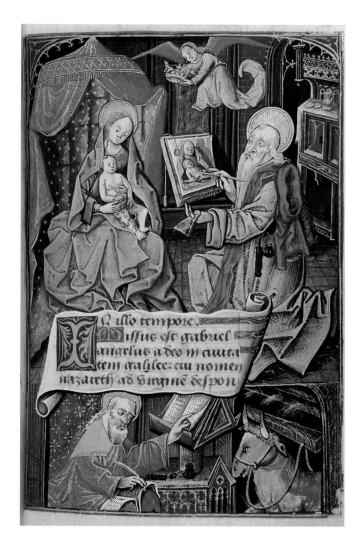

11 St Luke the Evangelist.
Central France; end of the
15th century. 150 × 100 mm.
Add. MS 20694, f.14.

Book of Hours painted in a style close to that found in manuscripts
produced by the Boucicaut and Egerton Masters. These two illuminators,
with the Master of the Bedford Hours, were leading figures in the Parisian
book trade during the first quarter of the 15th century. The marginal
decoration of this delicate piece includes, along with singing angels, a pair
of purely secular putti fencing with windmills. The arms of an early owner
have been painted out in the lower margin.

In the final decade of the 15th century one of the leading artists of the
Ghent-Bruges school of Flanders produced for a wealthy patron an
extremely sumptuous and large-scale Hours with 75 full-page miniatures.
Each of the conventional subjects in its Little Office is accompanied by a
complementary scene from the Old Testament, representing the episode
commonly taken as a prefiguration of the New Testament event. In the
case of the Annunciation (**15**), this is Moses and the Burning Bush (**16**).

Both scenes are set in contemporary Flanders and surrounded by borders of gilded gothic tracery. The artist is usually known as the Master of James IV of Scotland in honour of one of his most celebrated patrons, but he has recently been identified with Gerard Horenbout, who later became court painter to Margaret of Austria, Regent of the Netherlands, and ended his career in England in the service of Henry VIII. There are no contemporary clues to the ownership of this book, but it is just possible that it was intended for Margaret of Austria herself at the time of her marriage in 1497 to the Infante Juan, heir to the thrones of Castile and Aragon and brother of Joanna the Mad. This was 17-year-old Margaret's second political alliance. She had been betrothed at the age of two to the Dauphin Charles, son of Louis XI of France, and was brought up at the French court. When he succeeded his father in 1489, Charles repudiated Margaret in favour of a neighbouring heiress, Duchess Anne of Brittany. Margaret's new husband survived only a few months and she was subsequently married to Duke Philibert of Savoy, whose death in 1504 left her a widow for the second time. For much of the remainder of her life she acted as

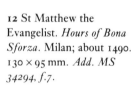

12 St Matthew the Evangelist. *Hours of Bona Sforza*. Milan; about 1490. 130 × 95 mm. *Add. MS 34294, f.7.*

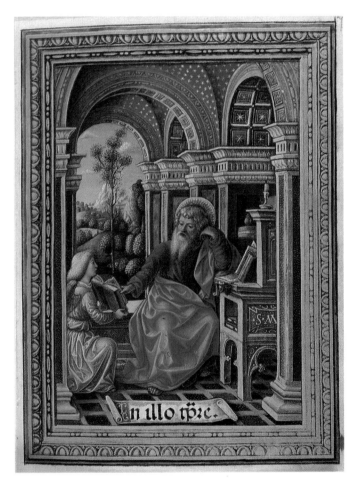

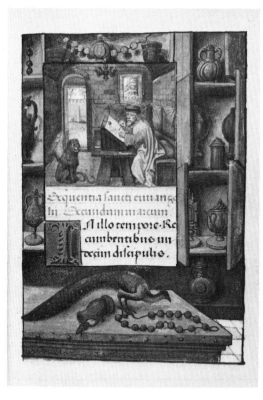

13 St Mark the Evangelist. *Hours of Joanna of Castile.* 110 × 75 mm. *Add. MS 18852, f.189.*

14 The Annunciation. Paris; early 15th century. 200 × 140 mm. *Add. MS 30899, f.1.*

15 The Annunciation. Bruges or Ghent; end of the 15th century. 240 × 150 mm. *Add. MS 35313, f.56b.*

16 Moses and the Burning Bush. Bruges or Ghent; end of the 15th century. 240 × 150 mm. *Add. MS 35313, f.57.*

Regent of the Netherlands for her nephew, son of Joanna the Mad and her own brother, Philip the Fair, who later became the Emperor Charles V. Her story exemplifies the important, if somewhat impersonal, use made of marriageable princesses – Margaret being the daughter of the Emperor Maximilian and Duchess Mary of Burgundy – in the power games of the Middle Ages and Renaissance.

Very different in concept from the Flemish manuscript, though not far removed from it in date, is a French Book of Hours which owes a self-conscious debt to Italian painting (17). References in its calendar connect it with Angoulême and include the dedication of the local cathedral. The parents of the future Francis I of France, Charles of Angoulême and Louise of Savoy, were well-known as patrons of the arts and employed a number of documented craftsmen including an illuminator named Robinet Testard. This manuscript, which on the one hand echoes the style of Botticelli and on the other that of the principal French court painter of the day, Jean Bourdichon, belongs within their circle.

Miniatures of the Visitation, involving no supernatural intervention but simply depicting the visit of the Virgin Mary to her cousin Elizabeth, mother of the Baptist, several times inspired illuminators to include direct references to their patrons. In the Hours of Laudomia de'Medici the reference is to the place rather than to the person involved in the commission (18). The scene is set against the church of San Lorenzo in

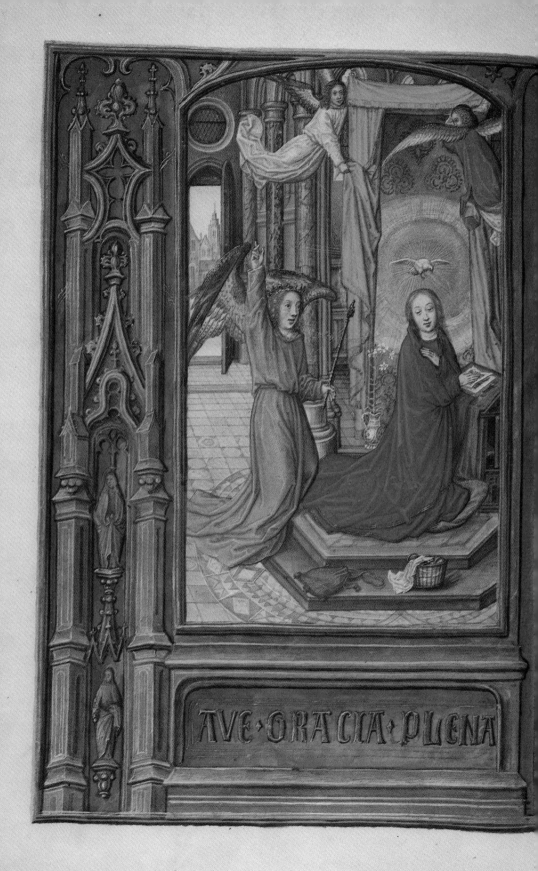

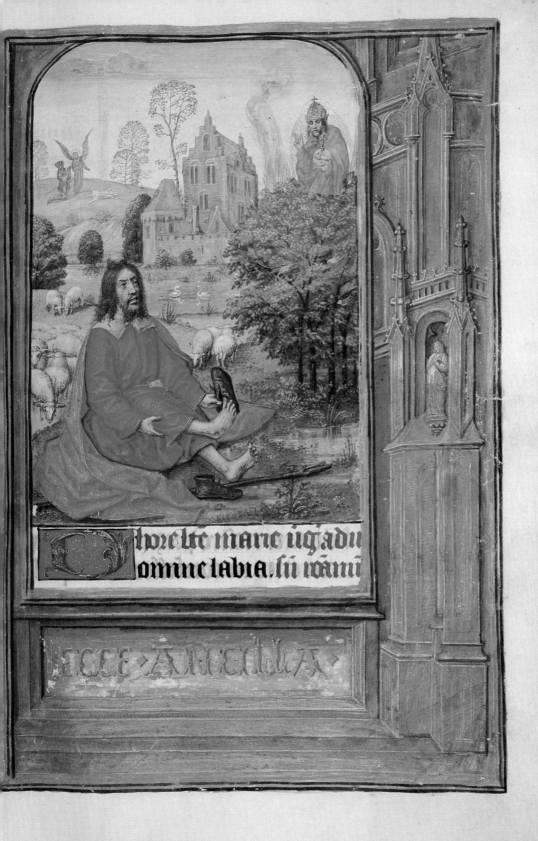

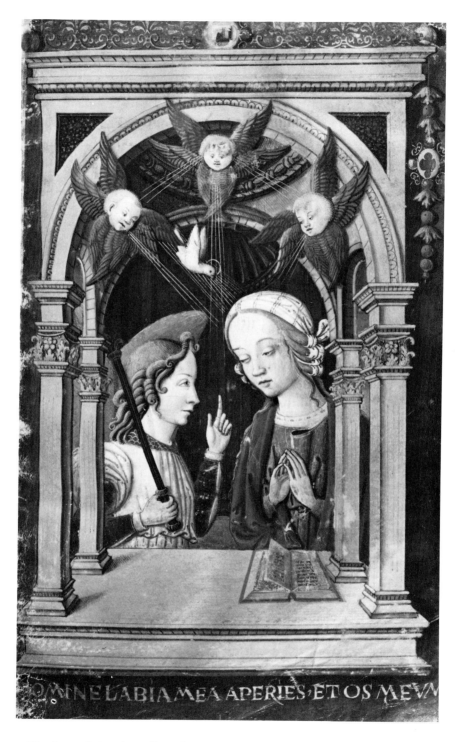

17 The Annunciation. Angoulême; about 1500. 240 × 155 mm.
Kings MS 7, f.7.

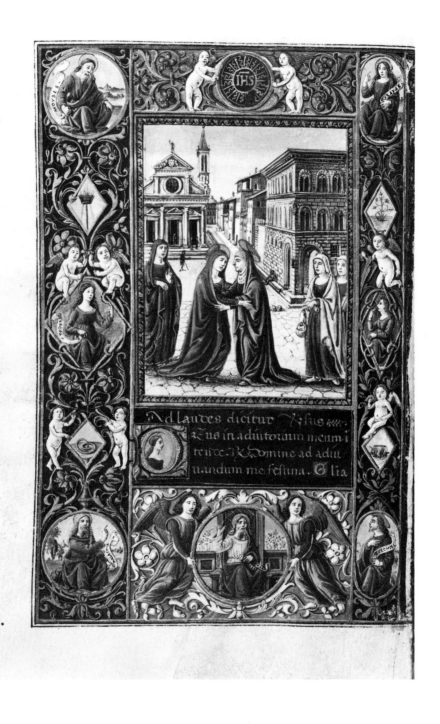

18 The Visitation. *Hours of Laudomia de' Medici*. Florence; about
1502. 180 × 120 mm. *Yates Thompson MS 30, f.20v*.

Florence, later to contain Michelangelo's Medici tombs, and the Medici palace is seen on the right of the picture. The artist of this page, Attavante degli Attavanti (*d.* about 1517), was the most successful Florentine illuminator of the day, his work owing much to the style of Ghirlandaio. The book was made on, or shortly after, it's owner's marriage to Francesco Salviati, which took place in 1502.

The Hours of Bona Sforza passed after her death to Margaret of Austria, widow of Bona's nephew, Duke Philibert of Savoy. In 1519 Margaret commissioned her court painter, Gerard Horenbout, to supply 16 miniatures to replace some of those which had been stolen from Birago's studio almost thirty years earlier. One of these is a Visitation (**19**) in which Margaret herself, wearing her distinctive white widow's headgear, is seen as St Elizabeth. Horenbout took great pains to copy the format and range of colouring which he found in the book's Italian miniatures but his landscapes and the faces of his characters are typically Flemish.

The Hours of Bona Sforza is a small manuscript but even it seems generous in scale when compared to one of the manuscripts produced in the studio of a French painter known as Maître François, who was active in

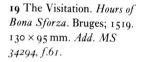

19 The Visitation. *Hours of Bona Sforza*. Bruges; 1519. 130 × 95 mm. *Add. MS 34294, f.61.*

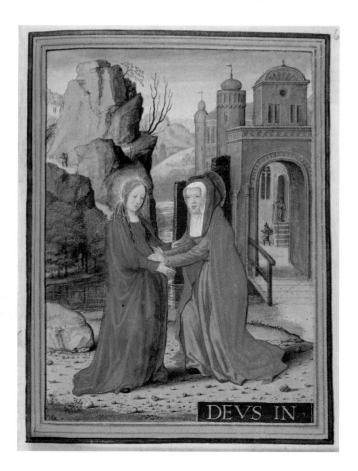

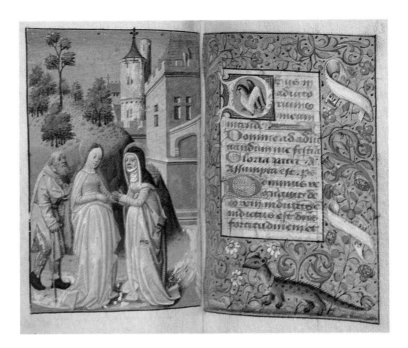

20 The Visitation. France; about 1470. 85 × 60 mm. *Egerton MS 2045, ff.62v–63.*

the Loire Valley about 1470 (**20**). This tiny Hours was probably once bound in precious metals and provided with chains by which it could be suspended from its owner's girdle. The minute figures which people its miniatures are dressed in subtle shades of mauve, white and grey, reflecting a contemporary taste for grisaille painting, though the landscape backgrounds are all fully coloured.

The humble stable in which Christ was born, sheltering its traditional gathering of animals, angels and human beings, was often somewhat glamourised in miniatures of the Nativity. A typically glossy version of the scene is provided by the Boucicaut Master in a small Book of Hours made during the first quarter of the 15th century (**21**). This manuscript is regarded as one of the finest works by an artist whose masterpiece is the great Hours made about 1410 for Jean le Meingre, Maréchal de Boucicaut, who was taken prisoner at Agincourt and died in captivity in England in 1421. It was later owned by Etienne Chevalier, Treasurer of France and patron of another great artist, Jean Fouquet.

More than a century later another Parisian workshop produced its version of the same scene (**22**). This artist was one of a group specialising in the production of elegant small-scale prayer books for the ladies of Francis I's court during the 1520s. The Roman script of the manuscript is not far removed from the work of the contemporary printers who, in Paris in particular, had by that date already usurped much of the everyday trade previously enjoyed by scribes and illuminators. The style and content of this painting reflect the work of the highly successful Antwerp Mannerist school of panel painters.

The close links between Renaissance illuminated manuscripts and contemporary panel painting are nowhere more obvious than in some of the late Flemish Books of Hours. The Nativity miniature in a particularly fine manuscript made in the early 1480s (23) appears in every respect like a small altarpiece, even lacking the traditional border of illusionistic flowers usually provided in manuscripts of this school. This miniature is attributed to the Valenciennes painter Simon Marmion (d. 1489), who worked with artists of the Ghent-Bruges school during the last few years of his life. He was responsible for some of the finest landscapes of the period.

Books of Hours survive so plentifully that even some of the most interesting are still totally unknown. A fine late 15th century French

21 The Nativity. *Chevalier Hours.* Paris; first quarter of the 15th century.
160 × 115 mm. *Add. MS 16997, f.57.*

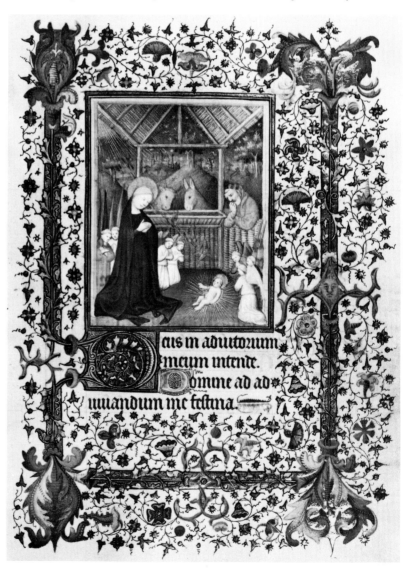

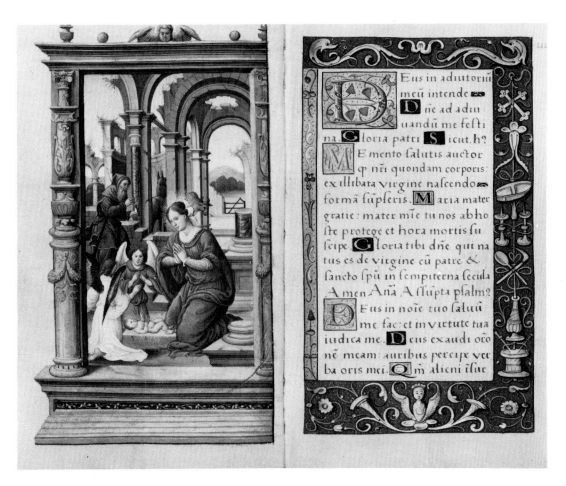

22 The Nativity. Paris; about
1525–1530. 140 × 90 mm.
Add. MS 35318, ff.43v–44.

manuscript, probably painted in or near Tours, divides several of its
subjects between two facing pages in the book. The shepherds arriving at
the stable to worship the infant Christ introduce Prime rather than Terce
(**24**). The artist was a follower of the fashionable court painter of the day,
Jean Bourdichon, whose landscapes and figure types he emulates, but he
shows considerable originality, not least in his use of the stable's roof line
to suggest continuity between his two picture spaces. The unusual choice
of soft green for the solid background colour in the margins provides an
admirable foil for the richer colours in the miniatures themselves.

 A far more elaborate scheme, this time preceding Terce, was devised by
one of the outstanding French illuminators of the mid-14th century, Jean
Pucelle (**25**), whose work betrays contact with development in other
European artistic centres of his period. He seems to have been particularly
influenced by the Sienese painter Duccio. In a tiny Book of Hours made
for Yolande of Flanders, on or after her marriage in 1353 to Philippe,
Count of Longueville and Valois, the son of Queen Jeanne II of Navarre,
Pucelle painted not only a detailed miniature of the shepherds with their
flocks, listening in wonder to the angel's message, but also a wealth of

subsidiary marginal scenes. These include figures of Sts George and Martin, and a procession to Calvary led by the blacksmith's wife who, according to legend, herself forged the nails for the Crucifixion. Unfortunately this delightful book was severely damaged by flood in 1846.

Grisaille is used to great effect throughout a manuscript written about 1450 for an Englishman but decorated by a well-known French illuminator. His Adoration of the Magi (**26**) is typical of the book, where even the border ornament is carried out in grey and white, only the faces of the characters and a few incidental details such as the star-studded sky being painted in colour. This artist is known as the Fastolf Master after his chief patron, Sir John Fastolf, a leading English soldier and public servant in France during the early years of Henry VI's reign there. The Master's earliest miniatures are found in manuscripts from the studio of the Bedford Master and he seems later to have worked in Normandy for English customers before crossing the Channel to England itself. There he

23 The Nativity. *Huth Hours.* Bruges or Valenciennes; late 1480s. 150 × 115 mm. *Add. MS 38126, f.75v.*

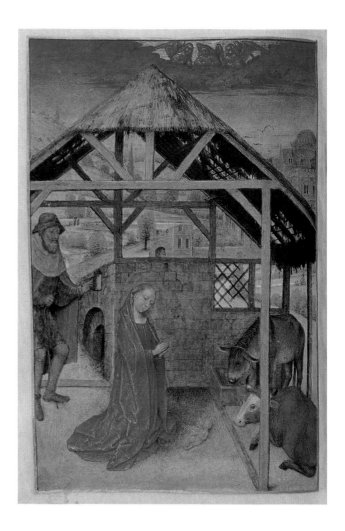

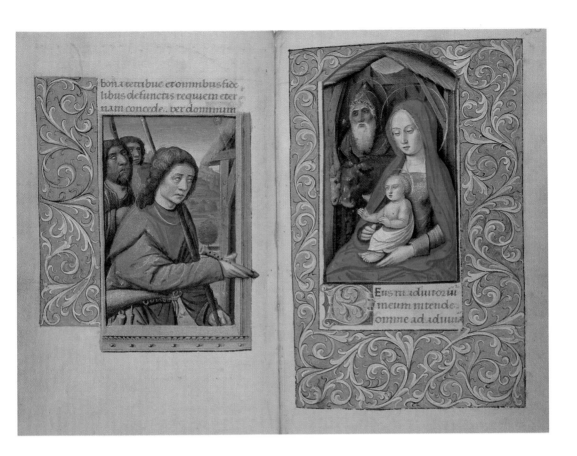

24 The shepherds adoring the Christ Child. France; end of the 15th century. 155 × 105 mm. *Harley MS 2936, ff.35v–36.*

was associated with a fine calligrapher called Ricardus Franciscus, whose elegant script is seen in this manuscript.

One of the most prolific Flemish artists of the last quarter of the 15th century, known to us from one of his manuscripts as the Master of the Dresden Hours, was responsible for the decoration of a delightful Book of Hours in which each part of the Office opens with a double page of decoration. His view of the Adoration of the Magi (**27, 28**) is surrounded by illusionistic borders of strewn flowers, so realistic that it seems possible to snatch them from the surface of the page, enclosing small subsidiary scenes. Two of these, in the lower margins, show further incidents from the story of the Three Kings. The other two, in the right-hand and left-hand margins, are devoted to Old Testament prefigurations of the story. On the left is King David, pouring out as an offering to God the water which had been brought to him at heavy cost from within beleaguered Jerusalem. On the right is the Queen of Sheba, with two attendants, bringing gifts to Solomon.

Early Italian Books of Hours with noteworthy decoration are comparatively rare. One example in the Library's collections includes a calendar pointing to Treviso, just north of Venice, as a possible place of origin. In this book, which dates from the 14th century, the Presentation of Christ in

the Temple (29), most frequently associated with None, introduces the Hour of Terce. Joseph, accompanying the Virgin and Child, is shown holding the two doves which were the customary offering for the occasion. The colouring and execution of this manuscript seem crude when placed beside illumination of the same period from northern Europe.

A French version of the same scene, in which the Jewish priest is garbed as a Christian bishop, appears in a Parisian manuscript probably made during the second quarter of the 15th century (30). The volume is one of a number bequeathed to the national collection in 1881 by William Burges, the Victorian architect and designer, whose own work was heavily influenced by medieval models.

The Flight of the Holy Family into Egypt, a standard choice as an introduction to Vespers, inspired a number of legends which do not appear in the New Testament narrative and these were often used by illuminators to give additional interest to their miniatures. In a French Hours written and illuminated in Paris about 1470 and related stylistically to the work of the fashionable Maître François, biblical and apocryphal sources are lavishly blended (31). The story of Joseph's dream is told on a scroll wound around the tree-trunks that enclose the main miniature. Inside a bejewelled frame the Holy Family crosses the foreground. Behind them a farmer is interrogated by Herod's soldiers. When the Virgin and Child rode by he was sowing corn in his field, and this miraculously

25 The Annunciation to the shepherds. *Hours of Yolande of Flanders.* Paris; about 1353. 110 × 75 mm. *Yates Thompson MS 27, ff.70v–70**.

26 The Adoration of the Magi. French artist working in England; about 1450. 175 × 125 mm. *Harley MS 2915, f.35.*

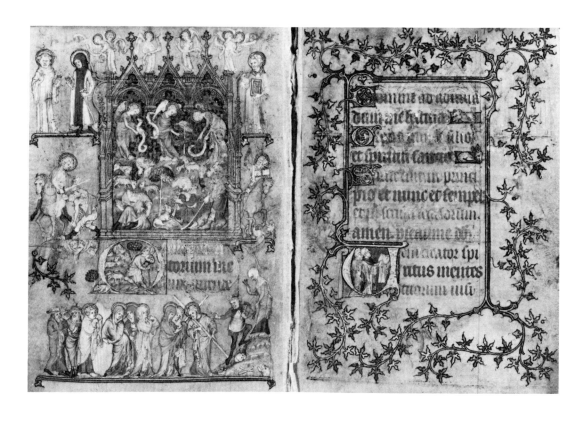

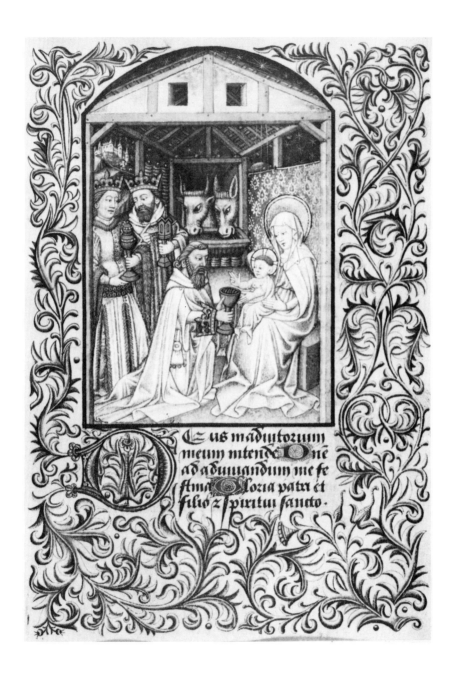

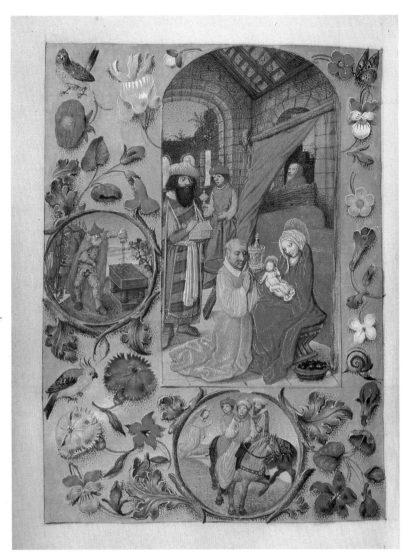

27, 28 The Adoration of the Magi (double page composition). Bruges; end of the 15th century. 150 × 110 mm. *Add. MS 17280, ff.197v–198.*

sprouted and was immediately ready for reaping, allowing him to tell his questioners with perfect truth that no-one had passed since he scattered the seed. Nearby is an idol that fell in pieces. The margins of the page are peopled with figures depicting the story of the Massacre of the Innocents.

A much simpler version of the same subject is offered by a Flemish painter, known to us by the somewhat cumbersome title of Master of the Prayerbooks of *c.* 1500 (**32**). He seems to have been based in Bruges and worked on occasion with the Master of the Dresden Prayerbook. Half-length figures are typical of his work and his landscapes are often inhabited by silhouettes of birds wheeling through the skies. Like Simon Marmion, he chose here to paint his miniatures without decorative borders, though the opening words of the text are enclosed within typical frames of

illusionistic flowers.

The Massacre of the Innocents, included as a subsidiary theme by some artists, takes pride of place in a miniature by one of the finest French illuminators of the end of the 15th century (33). The identity of this painter is still unclear, but he was certainly active in the Loire valley, probably at Bourges, and his style descends from that of the greatest French painter of the century, Jean Fouquet of Tours. He had a strongly developed sense of drama, a great talent for characterisation and a facility for portraying distant landscape that at its best rivals that of Fouquet himself. These aspects of his work are all to be seen in his interpretation of the murder of the children of Bethlehem, which is accompanied in the lower margin by a vignette of the Holy Family on the road to Egypt.

The last of the eight Hours of the Little Office of the Blessed Virgin Mary, Compline, is usually introduced by a miniature showing some aspect of the story of her death, Assumption and Coronation. These events, like the miracles associated with the Flight into Egypt, are drawn from apocryphal sources but had strong popular appeal. A fine traditional example of the Coronation of the Virgin occurs in an Hours of Bourges use dating from about 1400 (**34**), to which several illuminators contributed. All of them are identical with, or closely connected to, artists who worked for the Duke of Berry, brother of King Charles V and one of the greatest patrons of the arts in medieval history. The book contains no signs of ownership, but it is probable that it was made for someone in the Duke's immediate circle.

Although these scenes from Christ's childhood are the commonest illustrations for the eight divisions of the Little Office, they were by no means invariably used. Particularly in England and in the Netherlands, subjects drawn from the story of Christ's Passion and Resurrection were frequently preferred. Passion scenes also often occur in Books of Hours as an accompaniment to the subsidiary Hours of the Cross or to introduce relevant extracts from the Gospels, and the Hours of the Holy Spirit will

29 The Presentation. Treviso; 14th century. 140 × 100 mm. *Add. MS 15265, ff.39v–40.*

30 The Presentation. Paris; second quarter of the 15th century. 245 × 175 mm. *Add. MS 31834, f.66.*

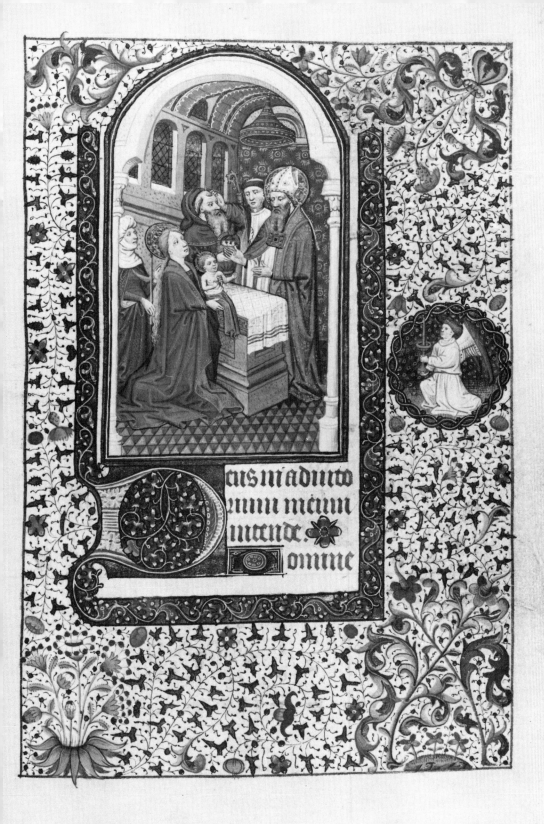

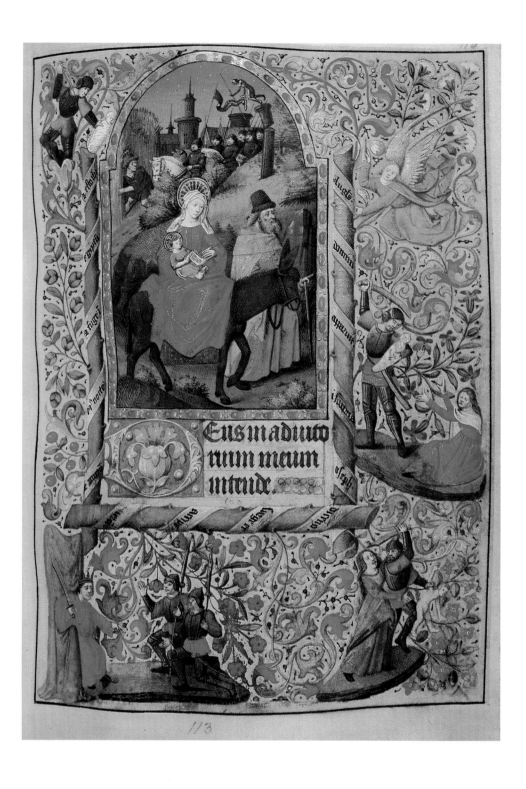

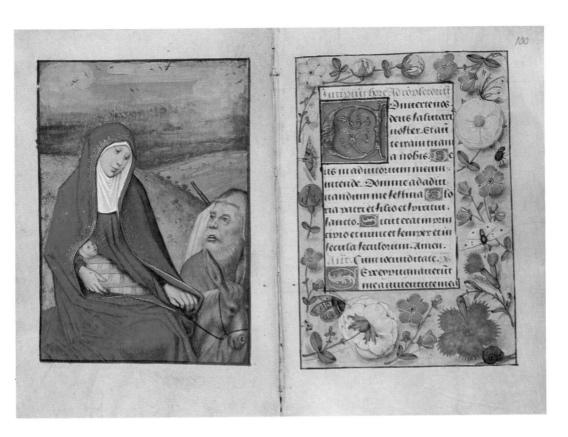

31 The Flight into Egypt.
Paris; about 1470.
190 × 135 mm. *Add. MS
25695, f.114*

32 The Flight into Egypt.
Bruges; about 1500.
135 × 95 mm. *Egerton MS
1149, ff.99v–100.*

be ornamented with a miniature of Pentecost. The treatment of these scenes is very varied and the examples given here, drawn from different contexts in their several books, represent only a tiny proportion of the material available for study.

In an outstanding manuscript painted by one of the earliest and finest illuminators of the Ghent-Bruges school, a miniature of Christ washing the feet of the disciples introduces a popular devotion on the Passion, attributed to St Bridget of Sweden (*d.* 1372) and known as the Fifteen O's (**35**). It is surrounded by a superb illusionistic floral border. The book was made for an Englishman, William, Lord Hastings, a courtier and close personal friend of King Edward IV, who is popularly remembered today as the man summarily executed at the Tower in 1483 by order of the future Richard III and immortalised in a famous scene by Shakespeare. There are numerous clues pointing to Hastings's ownership, including badges of the Order of the Garter, coats-of-arms and a rare miniature of St David of Wales as a prince, in reference to Edward, Prince of Wales, son and heir of Edward IV and famous in history as the elder of the two ill-fated Princes in the Tower.

Christ's arrest in the Garden of Gethsemane, betrayed by the kiss of

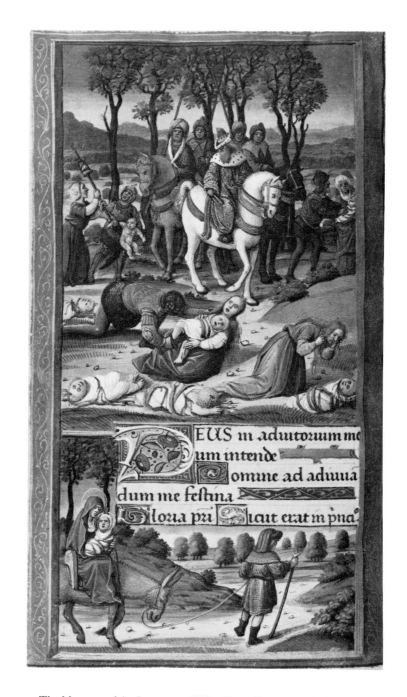

33 The Massacre of the Innocents. *Tilliot Hours*. Bourges; end of the 15th century. 180 × 110 mm. *Yates Thompson MS 5, f.54v.*

34 The Coronation of the Virgin. Bourges; about 1400. 190 × 140 mm. *Yates Thompson MS 37, f.72.*

Judas, precedes St John's account of the Passion in a book written and illuminated in France in 1525 (36). The very linear style of the work in this manuscript relates it to the decoration in the many printed editions of the Hours which were in production at the time. Its artist has made a valiant attempt to portray the darkness of the night, his figures high-lighted in gold against an ink blue ground. The original owner of this Hours was François de Dinteville, Bishop of Auxerre, which serves as a reminder that the private recitation of the Little Office was not confined to the laity.

Some of the earliest surviving independent Books of Hours were made in England, though this type of prayer book never achieved there the immense popularity which it enjoyed in France and Flanders. A magnificent example dating from about 1275–80 is the Salvin Hours, which takes its name from the north country family which owned it at least as early as the 17th century. A cycle of Passion scenes punctuates its Little Office, with a miniature of Christ before Pilate enclosed within the initial at the beginning of Terce (37). The book was designed for use in the diocese of Lincoln, which in the 13th century embraced much of central England, including Oxford where it was perhaps produced.

Christ carrying the cross along the road to Calvary introduces the Hours of the Cross in a small manuscript painted in France during the last decade of the 15th century (38). Its artist, Jean Bourdichon, was one of the best and most successful painters of his day, a close follower of Jean Fouquet of Tours and servant to four successive kings of France. His masterpiece is a large and sumptuous Book of Hours produced about 1508 for Anne of Brittany, Queen first to Charles VIII and then to Louis XII. As court painter Bourdichon was required to undertake a wide variety of artistic work and he is last heard of in 1520, contributing to the decoration of the pavilions for the meeting of Francis I and Henry VIII at the Field of the Cloth of Gold.

The first known separate Book of Hours by an English illuminator was made about 1240. Its artist, who was responsible for a number of manuscripts decorated in a distinctive and somewhat idiosyncratic style, several times signed himself 'W. de Brailes' and he was almost certainly the craftsman of this name who appears in 13th century Oxford records as living in Catte Street, then the centre of the local book trade. De Brailes used the Passion cycle to introduce the Hours, and the Crucifixion appears before None (39). Two supplementary scenes, one including the Virgin and St John and the other showing Christ's side pierced by a spear, are placed below the main picture. The manuscript retains a medieval binding which cannot be much later than the date at which it was written.

Approximately half a century later an illuminator in the Low Countries, living and working in or near Maastricht, produced a very tiny Hours with lavishly gilded miniatures. Vespers begins with a miniature of the Descent from the Cross and an initial enclosing the Entombment (40). The surrounding decoration includes the symbols of the Four Evangelists and a group of clerics chanting from a large-scale choir book. Marginal figures

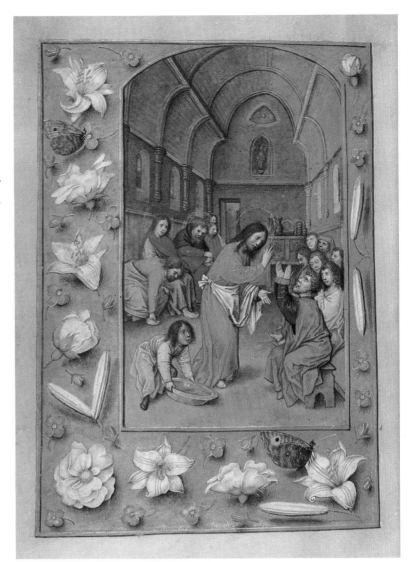

35 Christ washing the feet of the disciples. *Hastings Hours.* Bruges or Ghent; before 1483. 165 × 120 mm. *Add. MS 54782, f.265v.*

elsewhere in the book are associated with the subjects of adjacent miniatures.

Also from the Low Countries is a miniature of the Harrowing of Hell, introducing Compline in a Book of Hours written entirely in Dutch (**41**). Christ, having broken open the doors of Hell, reaches out his hand to help Adam and Eve climb up from the pit. The manuscript was made about 1410–20 in the region of Utrecht or Guelders and contains 66 illustrations which are among the most interesting and original Dutch works of their day, though their lack of frames and limited range of pigments gives them a deceptively primitive appearance.

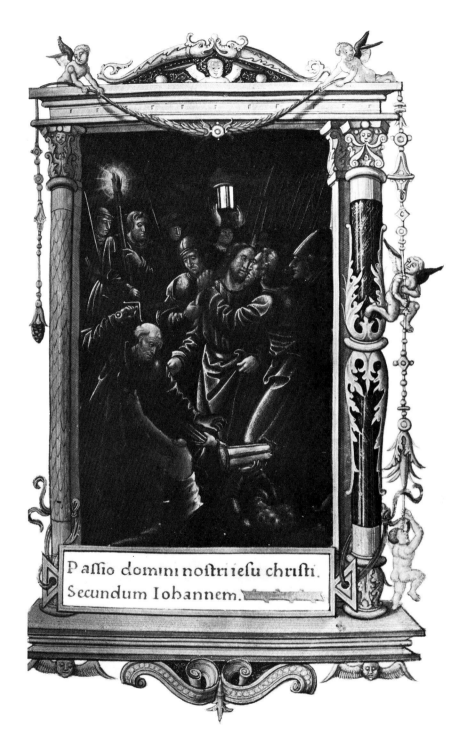

Passio domini nostri iesu christi.
Secundum Iohannem.

36 The arrest of Christ. *Hours of François de Dinteville*. France;
1525. 245 × 160 mm. *Add. MS 18854, f.18.*

eus qui salutis eterne beate
marie uirginitate secunda
humano generi premia pres
titisti. tribue quesumus ut ip
sam pro nobis intercedere sentiamus per
quam meruimus auctorem uite suscipe
p dominum nrm. Ad terciam.

eus in
adiuto
rium
meum
intende

Domine ad adiuuandum me festina.
Gloria patri et filio et spiritui. s. Sicut.
eni creator spiritus mentes
tuorum uisita imple supna
gratia que tu creasti pectora
e meto saluns auctor qd

37 Christ before Pilate. *Salvin Hours*. England, possibly Oxford;
about 1275–1280. 320 × 210 mm. *Add. MS 48985, f.32v.*

45

Of similar date to the Dutch Book is the Hours of Elizabeth the Queen, so called because it was later owned by Elizabeth of York, Henry VII's wife. A miniature at the beginning of the Psalms of the Passion shows Christ the Redeemer, flanked by the Virgin and St John and overshadowed by the Cross, emerging from a splendid contemporary tomb complete with sculptured figures of weepers (42). Although this manuscript was made in England and indeed represents the very finest and most typical English work of its period, its style is strongly influenced by the art of the lower Rhineland, which was fostered by a celebrated immigrant artist, Herman Scheerre, with whom the chief illuminator of the Hours of Elizabeth the Queen, a man called John, was closely associated.

38 Christ carrying the Cross. Tours; end of the 15th century. 145 × 95 mm. *Harley MS 2877, f.44v.*

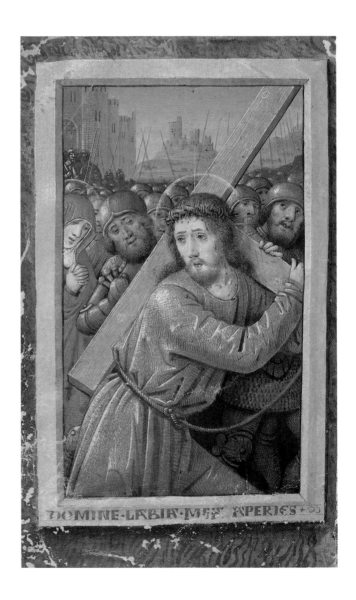

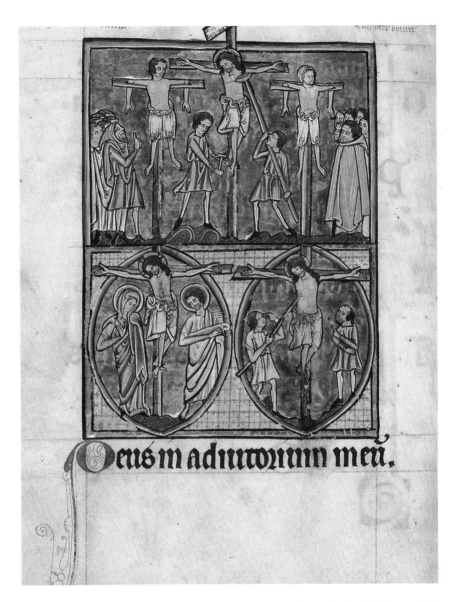

39 The Crucifixion. *De Brailes Hours*. Oxford; about 1240. 150 × 120 mm. *Add. MS 49999, f.47v.*

A good example of a Pentecost miniature, introducing the Hours of the Holy Spirit, comes from a manuscript written and illuminated in Paris about the middle of the 15th century (**43**). The descent of the Holy Dove upon the assembled Virgin and Apostles is shown in the main picture, and this is surrounded by supplementary marginal scenes which include episodes from the story of the Creation and representations of the sacraments of baptism and penance.

In a small number of Books of Hours subjects for miniatures, often relating to miracles, are drawn from parts of the gospel story and from apocryphal sources other than those relating to Christ's childhood and Passion. A small-scale manuscript written and illuminated in Bologna

towards the end of the 14th century offers as an introduction to Vespers an illustration of the Virgin Mary leaving her parents and ascending the steps of the Temple (44). According to tradition, Christ's mother was educated within the Temple precincts. This book, seemingly connected with the local Augustinian abbey of San Salvatore, is decorated in a style descended from that of a very famous Italian illuminator, Niccolò da Bologna.

A slightly later Italian Hours, made in Verona in the early 15th century, also employs scenes from the legendary life of the Virgin. Sext begins with a miniature of her marriage to St Joseph (45). The book is a particularly small one, written out in a rather large script.

One of the earliest English Books of Hours, probably produced about 1325, contains a large and extraordinarily varied selection of scenes, among which are episodes from the apocryphal stories of Christ's childhood. Prime opens with an illustration of a rare and somewhat less than edifying miracle whereby he transformed some children, hidden in an oven, into a herd of swine (46). This manuscript is very richly decorated and contains lavish quantities of gold, so its anonymous patron must have been a person of considerable wealth.

The Hours of Amadée de Saluces, already mentioned as the subject of the cover illustration, includes a number of extremely unusual scenes from the New Testament. The marriage at Cana, shown in the guise of a noble wedding party of the mid-15th century, stands at the beginning of Prime (47). The traditional subject for this place, the Nativity, is relegated to the interior of the initial with which the service begins. The very large scale of

40 The Descent from the Cross and the Entombment. Maastricht; about 1300. 95 × 70 mm. *Stowe MS 17, ff.116v–117.*

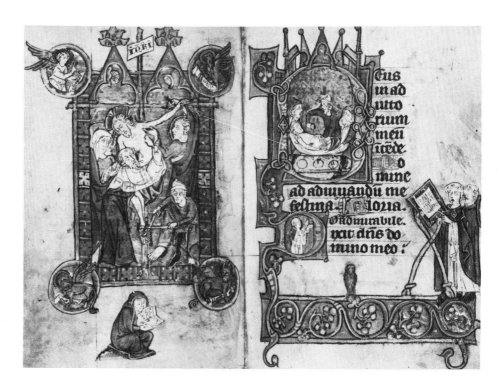

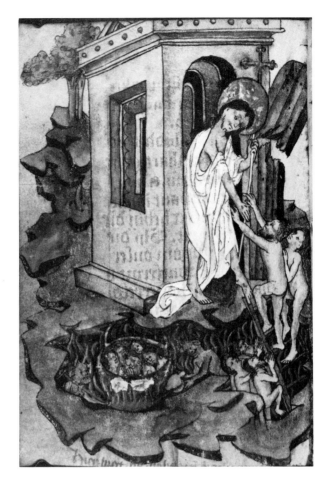

41 The Harrowing of Hell.
Utrecht or Guelders; about
1410–1420. 125 × 85 mm.
Add. MS 50005, f.131v.

the manuscript enabled its illuminators to introduce a lot of incidental details such as the vessels on the table, the manservant drawing water from the well and the maidservant cooking in the kitchen.

A lady who was apparently a member of the royal family was the original owner of another early 14th century English manuscript, the Taymouth Hours, but her exact identity has so far proved elusive. The manuscript contains almost 400 separate illustrations, many of them placed in the margins, and explanatory 'captions' in French (the normal everyday language of the English upper classes of the time) are provided at the foot of each page. The miracle of the Feeding of the Five Thousand is an exceptional choice for the beginning of None (**48**). The book is illuminated in the late 'East Anglian' style, betraying a certain amount of influence from French illumination of the period, though it lacks the smooth sophistication of the contemporary French work.

A miracle which is quite frequently found in Book of Hours, often as an introduction to the Office of the Dead, is the Raising of Lazarus (**49**). In a version painted about 1500 by a Flemish illuminator of the Ghent-Bruges school, the event takes place in a late medieval churchyard. A touch of

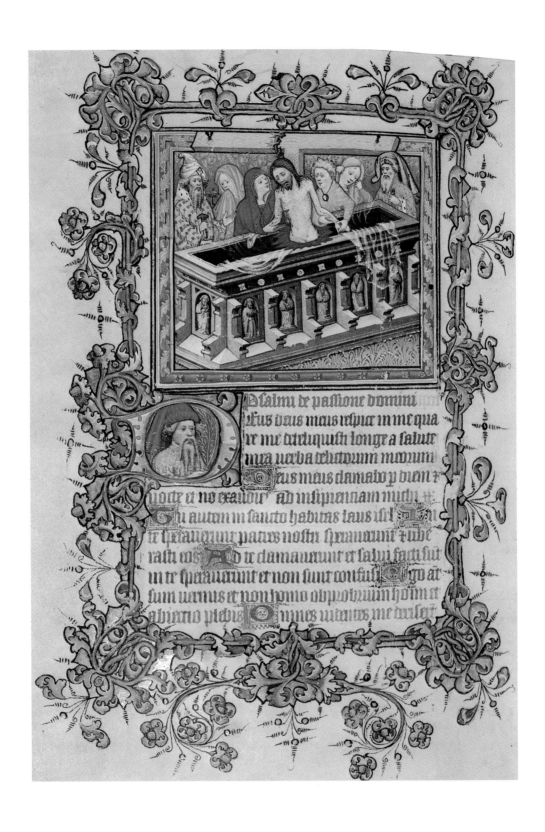

Psalmi de passione domini
Eus deus meus respice in me qua
re me dereliquisti longe a salute
mea uerba delictorum meorum
eus meus clamabo p diem r
noctè et nõ exaudis Ad insipienciam michi
Tu autem in sancto habitas laus isr̃
te speraumut patres nostri sperauerunt et libe
rasti eos Ad te clamauerunt et salui facti sut
in te speraumut et non sunt confusi Ego aũt
sum uermis et non homo obprobrium hõm et
abiectio plebis Omnes uidentes me deriseq

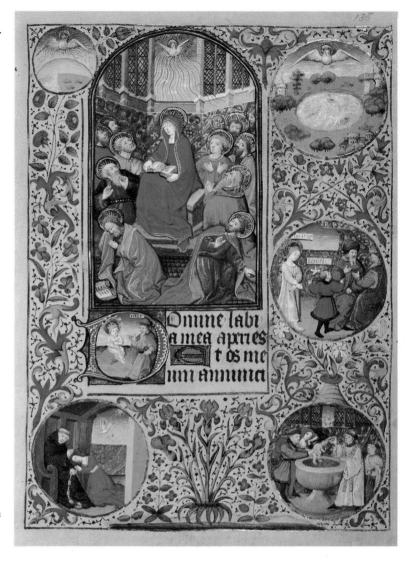

42 Christ the Redeemer. *Hours of Elizabeth the Queen.* England; first quarter of the 15th century. 205 × 140 mm. *Add. MS 50001, f.74v.*

43 Pentecost. Paris; mid 15th century. 195 × 140 mm. *Egerton MS 2019, f.135.*

realism is added by one of the gravediggers who is shown clasping a hand over his nose in anticipation of the odour of decay expected to arise from the corpse.

The Office of the Dead, which is a standard feature of the majority of Books of Hours, provides some of the most original miniature subjects, reflecting the eternal and universal fascination of the subjects of death, doom and disaster. The more conservative illuminators tended to settle for illustrations of various aspects of the funeral rites, shown in the settings and with the accessories of their own times. In an Hours made about 1440 for a member of the Crémeaux family living in the Lyons district of France, a sheeted corpse, sprinkled with holy water, is laid in its grave,

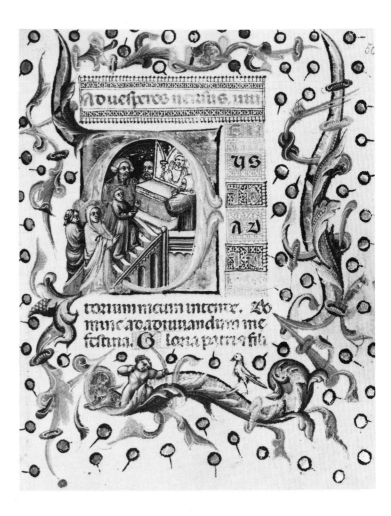

44 The Virgin Mary entering the Temple. Bologna; end of the 14th century.
130 × 100 mm. *Add. MS 34247, f.50.*

attended by a large group of mourners (**50**). Tiers of skulls peer from a charnel house in the background and St Michael and the devil are seen in the sky, struggling for possession of the dead man's soul. The lower margin is suitably embellished with the figures of a Pope and an Emperor menaced by Death riding upon a black horse.

Another manuscript made in France during the second quarter of the 15th century, this time for an English patron, shows a requiem mass in progress with two male mourners, no doubt members of the dead man's family, kneeling in the foreground (**51**). The calendar of this book includes added entries commemorating the marriage of John and Eleanor Umfray in 1453 and the birth of their daughter Joan in the following year.

One of the leading book painters in early 16th century France, known to us as the Master of Claude of France because two of his finest manuscripts were ordered for Claude, daughter of Louis XII and Anne of Brittany and first wife of Francis I, specialised in small-scale devotional books. One of these, particularly noteworthy for the beauty and delicacy of the italic

script in which it is written, includes a striking miniature of Death riding upon a bull (52), a strange subject which appears quite frequently in French manuscripts of the time. The choice of script is unusual, for italic is more commonly associated with scholarly than with liturgical texts.

From Renaissance Italy comes a Book of Hours made for Galeotto Pico della Mirandola, Prince of Mirandola (*d.* 1499) and his wife Bianca, daughter of Niccolò III d'Este, Marquis of Ferrara. This contains a personification of Death as the 'Grim Reaper', standing in triumph with his scythe within a grand Italian palace (53). The Latin motto 'Omnia mors equat' ('Death makes all equal') appears above his head and the message is underlined by the marginal decoration in which the traditional headgear of the princes of church and state is interspersed with skulls, bones and serpents. At the foot of the page an angel sounds the Last Trump. The artist was a craftsman of the Paduan or Venetian school and his work, very classical in tone, is clearly influenced by the painting of his great contemporary Andrea Mantegna, who worked in Venice and died in 1506.

Like the Office of the Dead, the seven Penitential Psalms, accompanied by a litany of the saints, are a standard feature in most Books of Hours. A suitable companion piece to the Mirandola vision of Death is the miniature which introduces this section in an Hours written and illuminated in France at the beginning of the 15th century. It portrays the

45 The Marriage of the Virgin. Verona; early 15th century. 125 × 90 mm. *Add. MS 22569, ff.120v–121.*

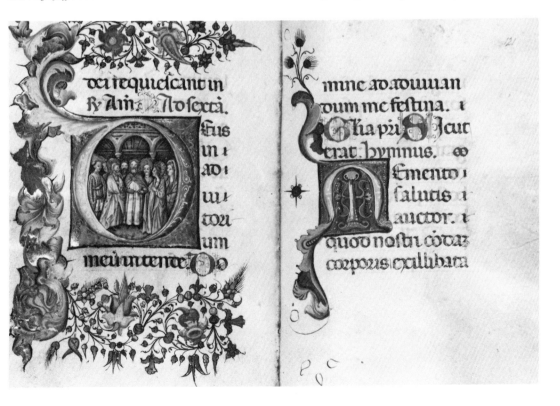

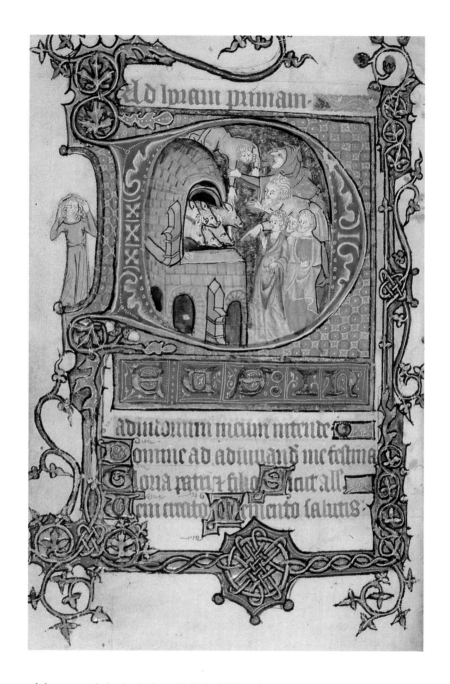

46 An apocryphal miracle from Christ's childhood.
England; about 1325. 170 × 110 mm. *Egerton MS
2781, f.88v.*

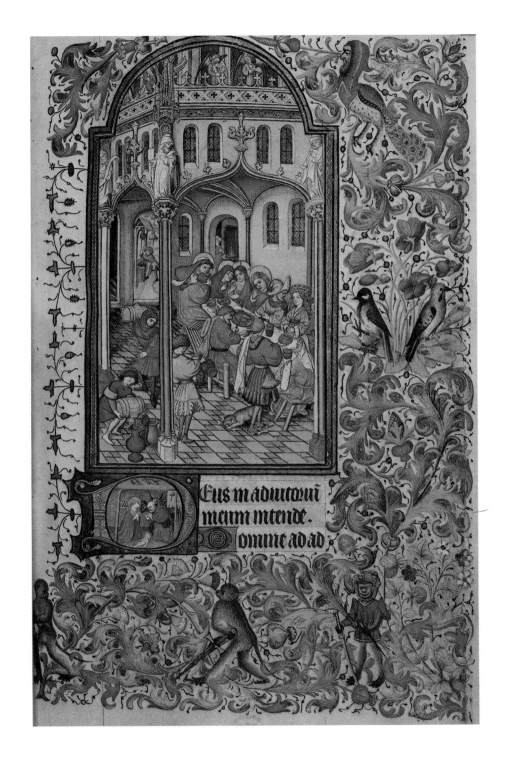

47 The Marriage at Cana. *Saluces Hours.* Savoy; third quarter of
the 15th century. 280 × 190 mm. *Add. MS 27697, f.49.*

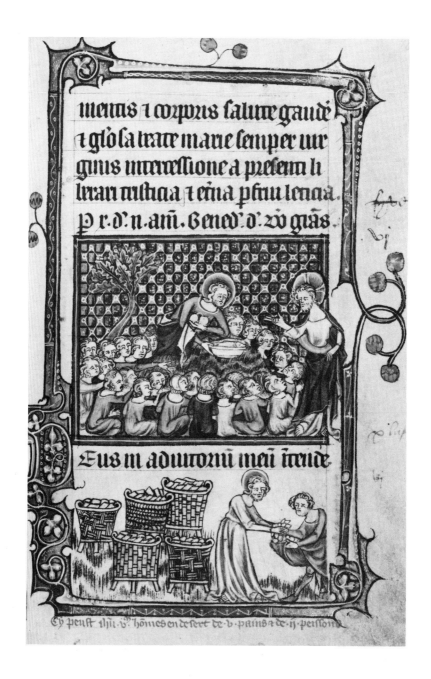

48 The Feeding of the Five Thousand. *Taymouth Hours.*
England; early 14th century. 170 × 115 mm. *Yates
Thompson MS 13, f.102.*

fate of the damned in graphic and horrifying detail worthy to stand beside Dante's celebrated description of it (**54**). The enthusiastic devils apparently specialise in the torture of churchmen, with a special emphasis on friars. The artist of this manuscript, though he lived in France and worked in partnership with some of the Duke of Berry's illuminators, may have been Italian by birth and was certainly trained in the tradition of the Bolognese master Niccolò.

It is more usual for the Penitential Psalms to begin with one or more scenes from the life of their traditional author, King David. The episode in which he kneels penitent before the Almighty is the subject of the British Library's only specimen of the work of Jean Fouquet of Tours, the leading French illuminator of the middle of the 15th century (**55**). This single leaf

49 The Raising of Lazarus. Bruges; about 1500. 160 × 105 mm. *Add. MS 35314, f.53v.*

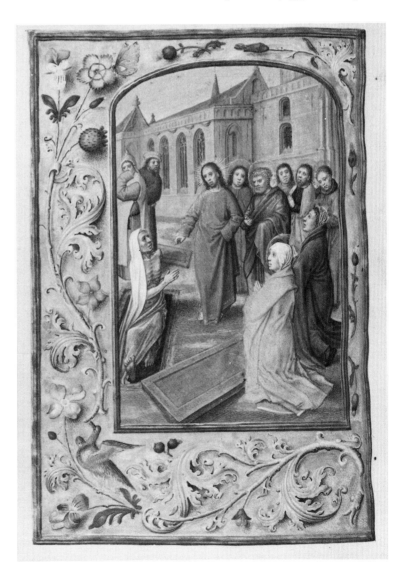

comes from the famous Hours of Etienne Chevalier, Treasurer of France in 1452, which was written and illuminated soon after 1450. The manuscript was broken up, probably about the time of the French Revolution, and 40 of the 47 surviving miniatures are now in the Musée Condé at Chantilly. Fouquet was the presiding genius of French painting during the latter half of the 15th century and his influence continued to be felt until well after 1500.

Fouquet was widely admired by his contemporaries and his innovatory techniques for the portrayal of light and space were adopted and refined by his successors. Even more universally admired by the artists of his own generation was Giulio Clovio, illuminator of the Stuart de Rothesay Hours. However, living roughly a century later than Fouquet, at a time when his craft had become a luxury for the wealthy dilettante, Clovio represents the end rather than the beginning of a trend in manuscript painting. He was Croatian by birth but spent most of his working life in Rome, where he was employed by the Cardinals Marino Grimani (*d.* 1546) and Alessandro Farnese (*d.* 1589). For the former he illuminated this manuscript, written out at an earlier date by the great humanist scribe Bartolomeo Sanvito. His picture of David (**56**) shows not a warrior on the battlefield but an old man at prayer, and the elaborate marginal decoration is strongly influenced by the monumental work current in the Rome of his day. The tiny scene of David and Goliath below the main miniature is a direct copy from the work of Michelangelo, to whom Clovio was himself compared by Vasari.

50 Burial. *Creméaux Hours.* France, possibly Lyons; about 1440. 195 × 140 mm. *Add. MS 18751, f.163.*

The story of David and Bathsheba apparently had considerable appeal for the painters and patrons of the Renaissance, especially in France. An Hours produced in the early 16th century by an unknown artist who seems to have been acquainted with the work of the Master of Claude of France provides a fine illustration of this subject (**57**). King David leans eagerly out of his palace window as the lady, naked and knee deep in water, accepts his letter from a messenger. Francis I seems to have seen himself as the new David and his amorous adventures certainly inspired comparison with some of the less reputable activities of the biblical monarch. This manuscript at one time belonged to the Vasselin family living in the Loire region of France and notes on their history are added to it.

Most Books of Hours include, in addition to the longer services and devotions, a selection of shorter prayers, one or two of which, such as the 'Obsecro te', have already been mentioned. These are usually accompanied by appropriate illustrations, such as the delightful miniature of the Virgin and Child in a rose garden which is found at the beginning of the 'Obsecro te' in a manuscript written and illuminated in Amiens during the 1430s (**58**).

In the Hours of William, Lord Hastings another short devotion to the Virgin is preceded by a sensitive image of the Holy Mother and her Child, framed by long golden curtains and surrounded by marginal flowers and butterflies in the very finest style of the Ghent-Bruges school (**59**).

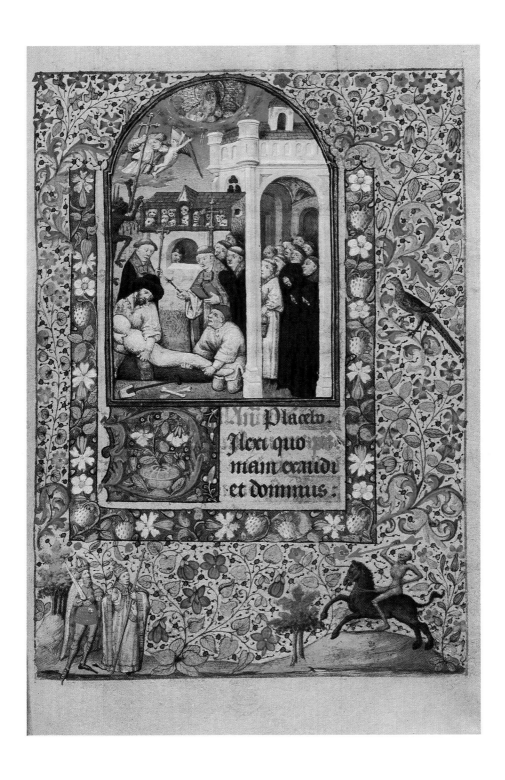

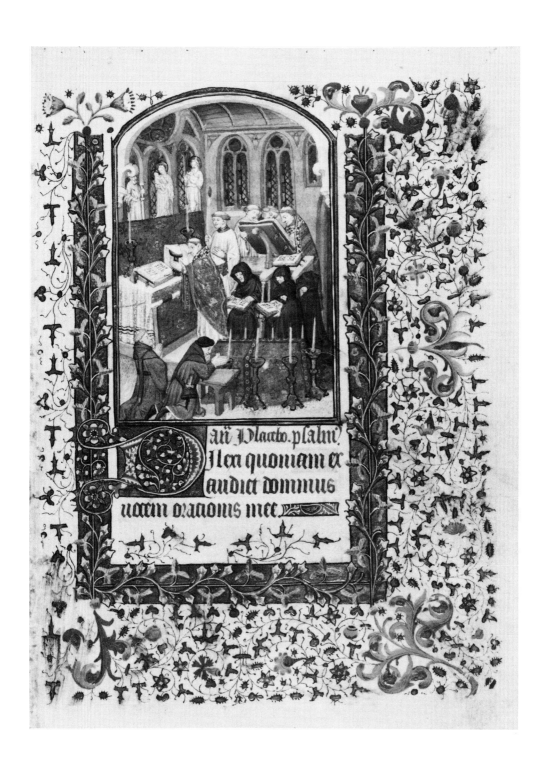

51 *Left* A Requiem Mass.
Umfray Hours. France;
second quarter of the 15th
century. 205 × 140 mm.
Sloane MS 2468, f.115.

52 *Right* Death riding upon a
bull. Paris; early 16th
century. 155 × 90 mm. *Add.
MS 35315, f.62v.*

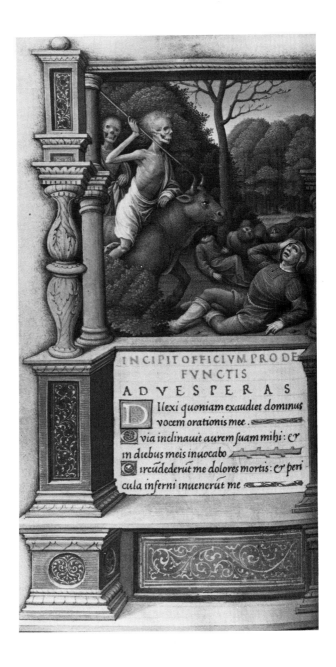

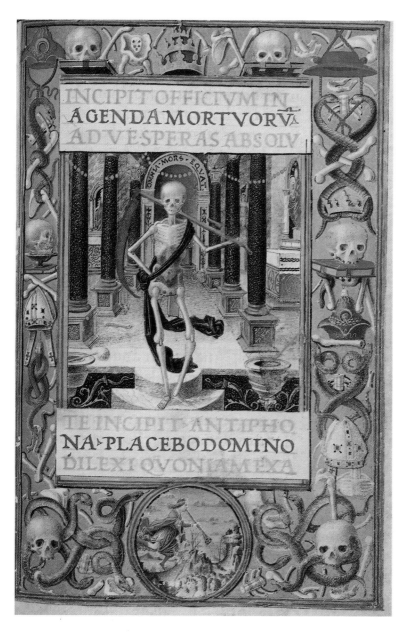

INCIPIT OFFICIVM IN
AGENDA MORTVORVA
AD VESPERAS ABSOIV

OMNIA · MORS · EQVAT

TE INCIPIT · ANTIPHO
NA · PLACEBODOMINO
DILEXI QVONIAM EXA

53 *Left* Death the 'Grim Reaper'. *Mirandola Hours.* Padua or Venice; before 1499. 165 × 115 mm. Add. MS 50002, f.85.

54 *Right* Hell. Paris; beginning of the 15th century. 220 × 160 mm. *Add. MS 29433, f.89.*

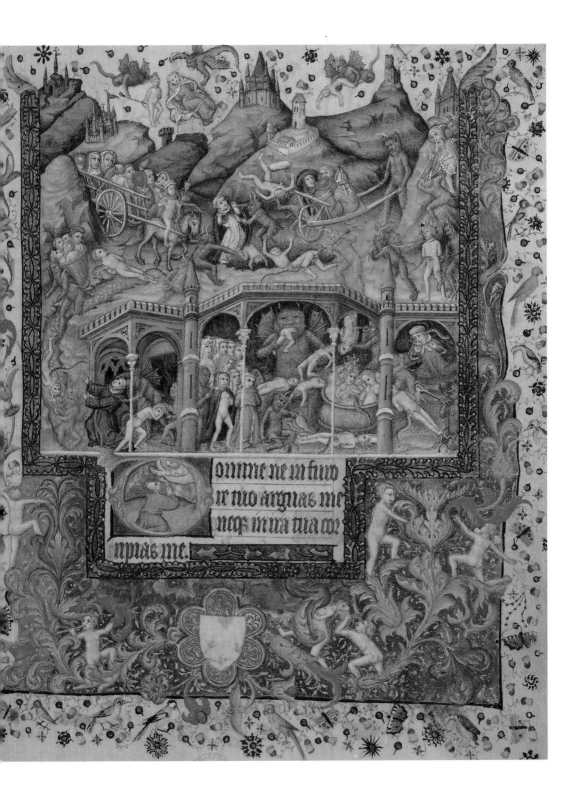

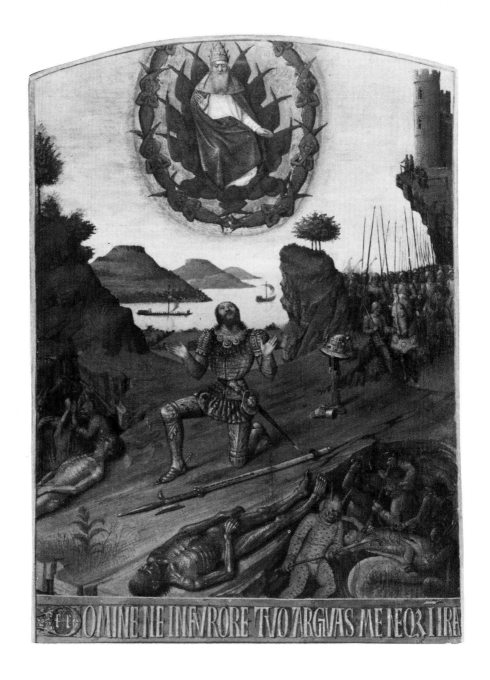

55 David Penitent. *Hours of Etienne Chevalier.*
Tours; mid 15th century. 150 × 120 mm (cut down).
Add. MS 27421.

56 David Penitent. *Stuart de Rothesay Hours*. Rome; mid 16th century. 135 × 90 mm. *Add. MS 20927, ff.91v–92.*

A miniature of the Seven Sorrows of the Virgin, represented by tiny illustrations of the relevant episodes from the life of Christ, introduces a short Office of Our Lady of Pity in an Hours written in 1535 at Barcelona by a scribe named Gregorius de la Placa (**60**). The text of the Office is in French except for its psalms, which remain in Latin. The style of the miniature is distinctly Flemish and the calendar includes a number of rather unusual English saints. The book is thus a fine example of the confused evidence which may confront an investigator and the arms of the original owner, which might offer some clarification, have so far resisted identification.

One of the several associates of the Bedford Master, known from his finest manuscript as the Master of Munich Golden Legend, was commissioned about 1435 to produce a Book of Hours for a wealthy but anonymous lady who was clearly determined to see her own personality very firmly stamped upon her new treasure. She had herself portrayed in scenes and marginal decoration at several points in the book, richly dressed in a scarlet gown and an elaborate headdress. At the beginning of a series of prayers to be said in preparation for Holy Communion (**61**) she is seen in church, participating at Mass. The men grouped in the margin are probably her husband and sons and the little ermine must be her personal

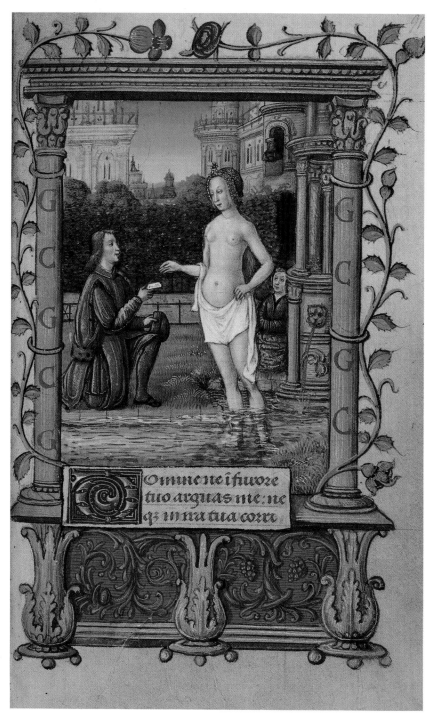

57 David and Bathsheba. *Hours of the Vasselin Family.*
North-west France; early 16th century. 205 × 125 mm.
Harley MS 2969, f.91.

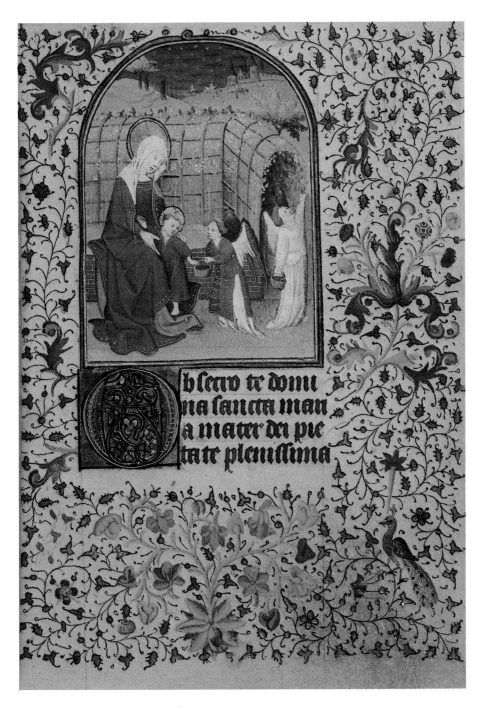

58 The Virgin and Child in a rose garden. Amiens; 1430s.
175 × 135 mm. *Add. MS 31835, f.27.*

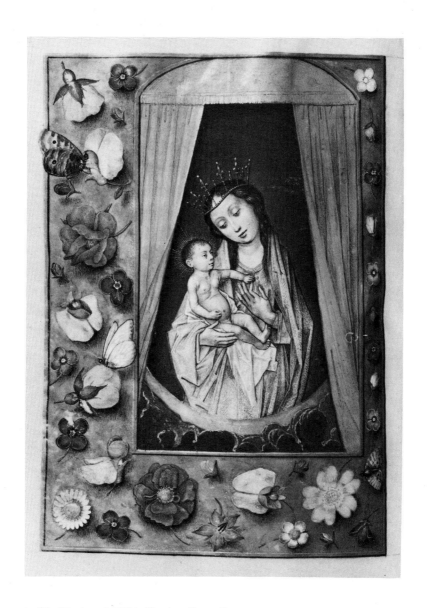

59 The Virgin and Child. *Hastings Hours.* Bruges or
Ghent; before 1483. 165 × 120 mm. *Add. MS
54782, f.59v.*

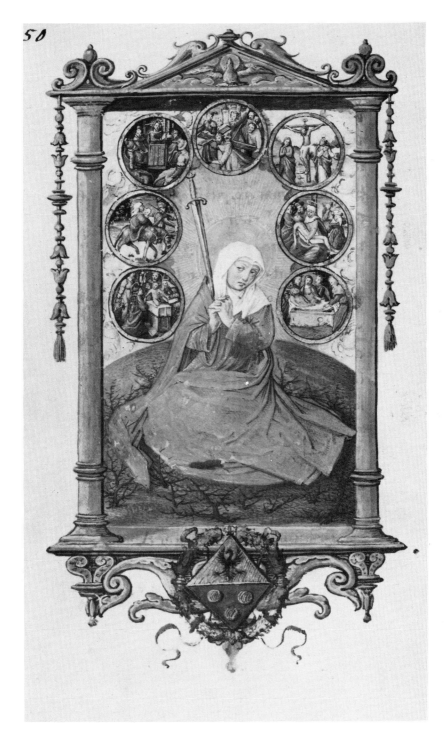

60 The Seven Sorrows of the Virgin. Barcelona; 1535.
185 × 120 mm. *Add. MS 35218, f.125v.*

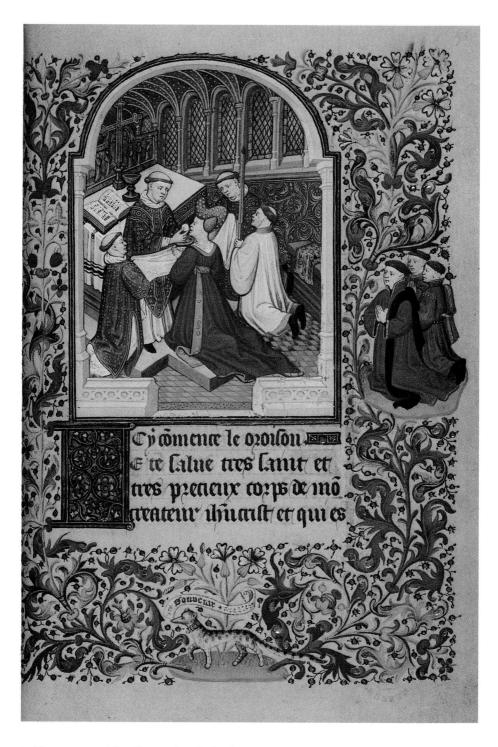

Cy comence le oroison
Te salue tres sanit et
tres precieux corps de mõ
sauueur ihucrist et qui es

61 The patron receiving Communion. Paris; about 1435.
195 × 130 mm. *Add. MS 18192, f.19v.*

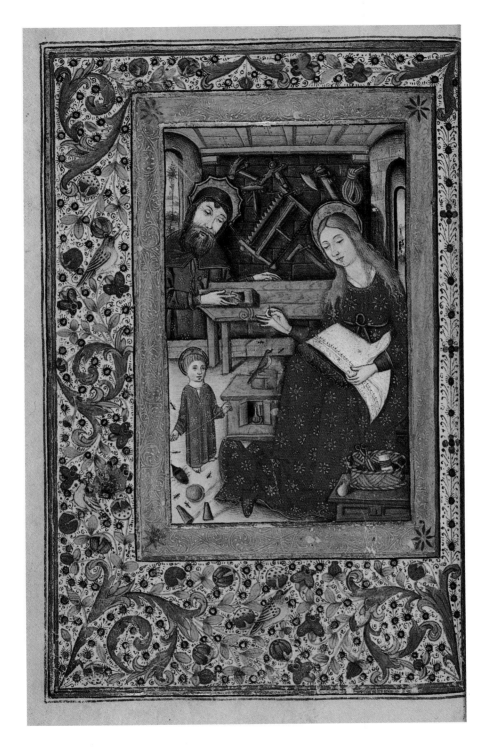

62 The Holy Family. Spain; second half of the 15th century.
195 × 135 mm. *Add. MS 18193, f.48v.*

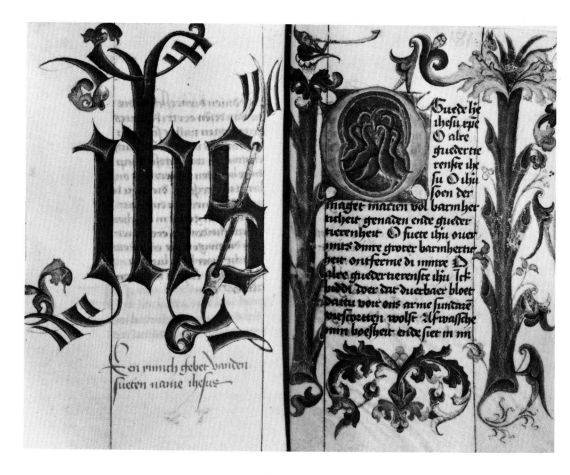

emblem. This artist worked for both French and English clients in the period which led up to the end of the English occupation of Paris.

A special Mass in honour of the Virgin is frequently found in Books of Hours. In a manuscript written and illuminated in Spain in the second half of the 15th century this begins with an illustration of the Holy Family in St Joseph's carpenter's shop (62). An array of tools hangs from the wall at the back of the picture, most of them very little different from those in use today. The Virgin is at work on some embroidery, her materials supported on a cushion and a work basket at her side. The Child has toys and a bird in a cage. The entire scene, save for the haloes, could represent an episode in the everyday life of the time,.

One of the Library's most interesting Dutch vernacular manuscripts includes a prayer on the theme of the name of Christ (63). This begins with a splendid full-page rendering of the monogramme 'IHS'. The manuscript was written and decorated somewhere in the area of the lower Rhine, probably during the third quarter of the 15th century, and it contains a number of miniatures derived from designs in contemporary engravings by a craftsman known as the Master of the Berlin Passion. It is

63 The monogramme of Christ. Lower Rhineland; third quarter of the 15th century. 140 × 95 mm. *Harley MS 1662, ff.184v–185.*

a reminder of the immense and widespread influence of the work of early printers whose compositions, reproduced in a multiplicity of copies, could be transmitted simultaneously to various parts of Europe widely removed not only from the original craftsman but also from each other.

Special prayers (known as Memorials or as Suffrages) addressed to individual saints are seldom lacking in a Book of Hours. Their subjects may be chosen from the principal saints of universal veneration or they may represent a more personal or local view. They are most usually to be found at the end of the manuscript though sometimes they are placed at the beginning and, in early English books in particular, they sometimes follow on after Lauds. They are generally arranged in the same order as the groups in the litany, beginning with the Trinity and progressing through Apostles, Martyrs and Confessors to Virgins and Widows. In some instances the inclusion of a saint whose cult spread very quickly after his death may offer a useful clue to the date of an otherwise puzzling book.

A distinctive French style is to be seen in a miniature of St John the Baptist painted about 1440 (64). He is seated in front of a superb landscape peopled with tiny wild animals. The outstanding quality of this particular artist's work at one time led scholars to suggest that he might in fact be Jean Fouquet at an early stage in his career. More recent research has revealed that he was actually a quite distinct personality whose workshop was apparently in Nantes, the seaport at the western extremity of the Rhône valley where the Dukes of Brittany had their principal residence. A substantial group of manuscripts has now been attributed to this hand.

Quite different is a manuscript painted in France at the end of the 15th century which includes a graphic and gory representation of the martyrdoms of St Peter and St Paul (65). St Peter insisted on being crucified upside down because he felt unworthy to die in the same manner as his Lord. St Paul had his head struck off with a sword. Subsidiary scenes from the lives of the two saints appear in the lower margin. The design of this page recalls the work of Fouquet and, perhaps more immediately, that of his followers such as the Master of the Tilliot Hours, whose strong sense of the dramatic is certainly echoed here.

St George, although universally popular, is given special prominence in manuscripts made for English patrons who had served in the French wars. He was said to have lived in Cappadocia and to have been martyred under Diocletian after suffering hideous tortures. The legend of the princess and the dragon, illustrated here (66), is apparently a romantic invention of the Middle Ages. This particular manuscript was made by a French illuminator, probably during the late 1420s, for Sir William Oldhall, a Norfolk man who, like John Duke of Bedford and Sir John Fastolf, spent much of his life as a soldier and officer of state in occupied France. He is seen in this miniature, fully armed and wearing a surcoat emblazoned with his coat-of-arms. Elsewhere in the book his wife, Margaret Willoughby, is portrayed kneeling before the Virgin and Child.

Reference to a popular legend also serves to identify St Jerome in a Flemish miniature of the early 16th century (67). The lion from whose

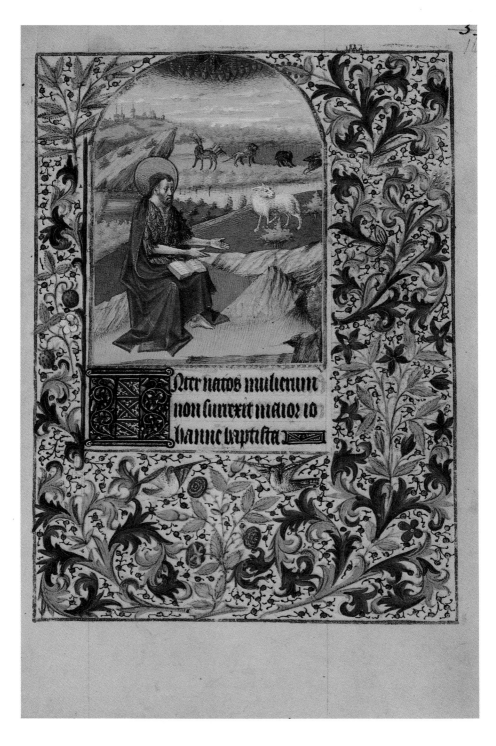

64 St John the Baptist. Nantes; about 1440. 190 × 140 mm. *Add.*
MS 28785, f.167.

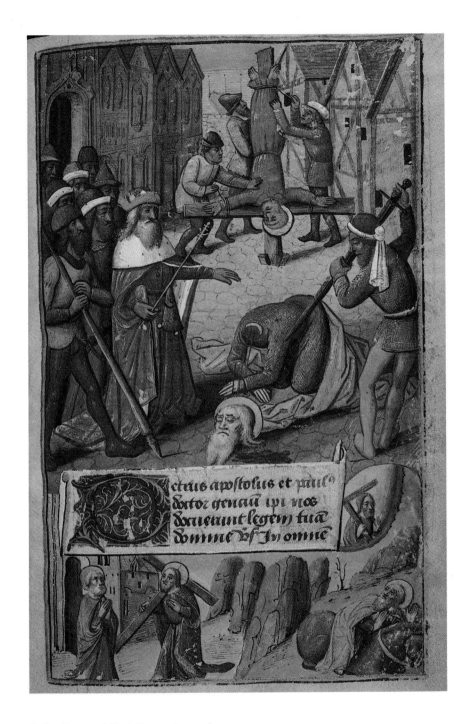

65 Sts Peter and Paul. France; late 15th century. 190 × 120 mm.
Add MS 11865, f.87.

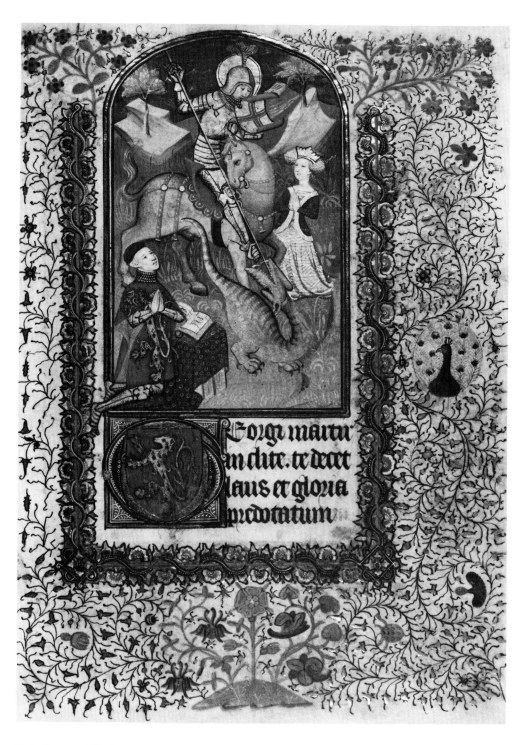

66 St George. *Oldhall Hours*. France; late 1420s. 240 × 155 mm.
Harley MS 2900, f.55.

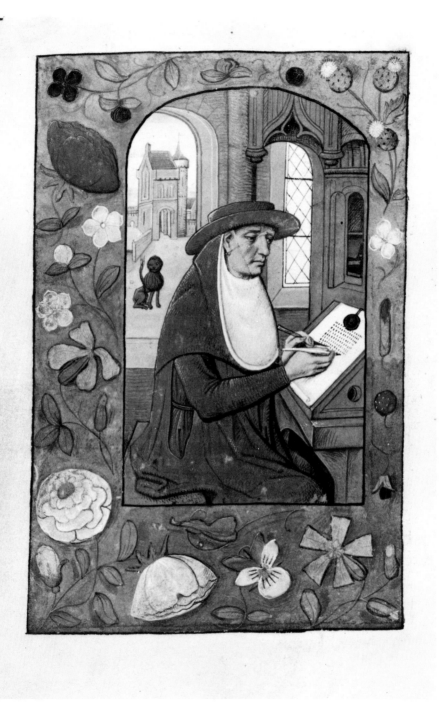

67 St Jerome. Flemish artist working in England; early 16th century. 190 × 125 mm. *Kings MS 9, f.240v.*

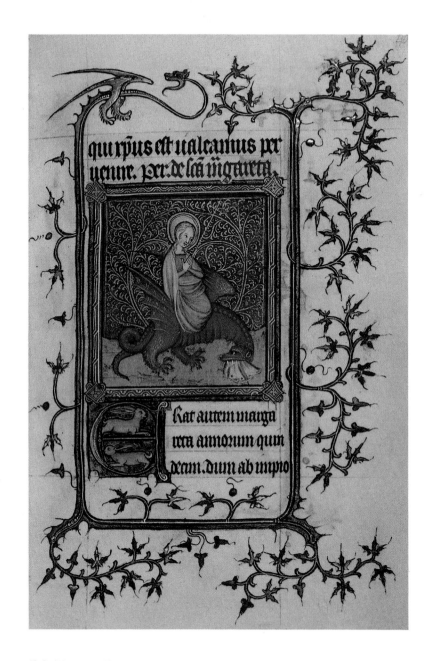

68 St Margaret. France; late 14th century. 175×115 mm. *Add. MS 23145, f.40.*

paw he is reputed to have withdrawn a thorn is seated demurely in the courtyard outside his study. Although the style of this manuscript is quite obviously Flemish, it is of Sarum 'use' and was probably made in England within the circle of the Tudor court. A number of Flemish artists, including Gerard Horenbout, were employed by Henry VII and Henry VIII. Both Henry VIII and his second wife, Anne Boleyn, have added inscriptions in marginal spaces in this book, suggesting that its owner regarded it as a kind of autograph album. The scratches on the saint's face probably date from the Reformation when both manuscripts and monuments were very frequently deliberately defaced.

One of the commonest of the female saints is Margaret, who was miraculously enabled to burst out through the back of a dragon that had been so foolish as to swallow her alive (**68**). She is simply but beautifully depicted in a small Hours written and illuminated in France at the end of the 14th century. This book dates from the period at which the Book of Hours was reaching its peak as a vehicle for the very finest of specimens of French painting.

The Books of Hours chosen for inclusion in this book represent only a small proportion of the very large collection of this type of manuscript to be found in the British Library. Most of these books are very richly illustrated, so that for each miniature reproduced here the same manuscript may contain dozens, occasionally hundreds, more. Some of the very greatest painters of the Middle Ages were employed upon the making of Books of Hours, which are therefore of basic importance to any student of the history of art. They are also a fundamental source for illustrations of the life of their times, for the study of popular religious cults and for the understanding of the history and development of early book production. To most people with a non-specialist interest in the Middle Ages and Renaissance, however, they present the popular ideal of the medieval illuminated book, intimate in scale and radiant with gold and colours. Modern developments in the art of colour printing have in recent years made possible the publication of a variety of convincing popular facsimile reproductions, so that Books of Hours are once again entering the best-seller class.

Suggestions for further reading

In recent years popular books dealing with illuminated manuscripts have become widely available. Most relevant in the present context is John Harthan, *Books of Hours* (1977), which includes reproductions from 34 outstanding examples of this type of manuscript in libraries all over the world and offers extensive notes and bibliography. Useful background material is provided by J J G Alexander, *Italian Renaissance Illuminations* (1977), François Avril, *Manuscript Painting at the Court of France: the Fourteenth Century, 1310–1380* (1978), Marcel Thomas, *The Golden Age: Manuscript Painting at the Time of Jean, Duc de Berry* (1979), and Richard Marks and Nigel Morgan, *The Golden Age of English Manuscript Painting, 1200–1500* (1981).

Many of the world's finest Books of Hours are individually covered by lavishly illustrated monographs. Of particular note is an edition of one of the most famous manuscripts in the world, *Les Très Riches Heures du Duc de Berry*, edited by Jean Longnon and Raymond Cazelles, with a preface by Millard Meiss (1969). Two of the manuscripts represented in this book have also been fully published: *The Hours of Etienne Chevalier*, edited by Claude Schaefer, with a preface by Charles Sterling (1972) and *The Hastings Hours*, edited by D H Turner (1983). Several other outstanding Books of Hours in the British Library are described and illustrated in an exhibition catalogue, *Renaissance Painting in Manuscripts: Treasures from the British Library* (1983).

Readers interested in the techniques practised by scribes and illuminators should consult books written for present-day exponents of these arts, such as *The Calligrapher's Handbook*, edited by C M Lamb (1954) and Marie Angel, *Painting for Calligraphers* (1984).

© 1985 The British Library Board
Reprinted 1988, 1995
Published by
The British Library
Great Russell Street
London WC1B 3DG

British Library Cataloguing in Publication Data

Backhouse, Janet
 Books of hours.
 1. Hours, Books of——History
 I. Title II. British Library
 091 ND3363.A1

ISBN 0 7123 0052 X

Designed by Roger Davies.
Typeset in Monophoto Ehrhardt by August Filmsetting, Haydock
Origination by York House Graphics Ltd., Hanwell
Printed and Bound in Great Britain by Clifford Press Ltd, Coventry

Front cover Amadée de Saluces at prayer before the Virgin and Child. *Saluces Hours.* Savoy; third quarter of the 15th century. 280 × 190 mm. Additional MS 27697, f.19.

Back cover Francesco Maria Sforza with his guardian angel. *Hours of Francesco Maria Sforza.* Milan; about 1493. 120 × 85 mm. Additional MS 63493, f.112v (detail).

Titlepage St Mark in his study. Bruges; early 16th century. 85 × 55 mm. Additional MS 32388, f.2. (Enlarged.)